Painting the Things You Love in Watercolor

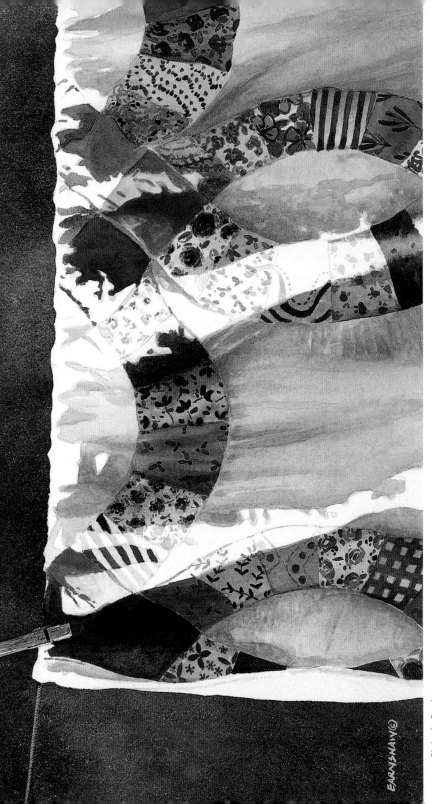

Birds of a Feather
Watercolor on 300-lb. (640gsm) cold-pressed paper
9" × 32" (23cm × 81cm)
Private collection

EARNSHAW ©

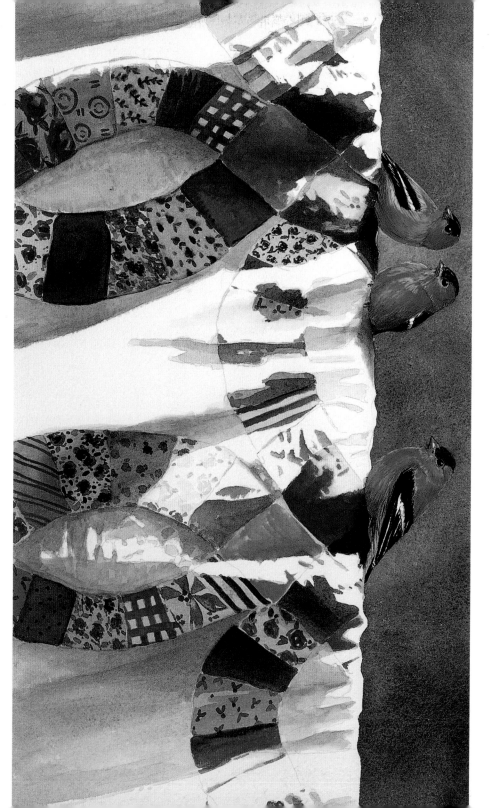

Painting the Things You Love

IN WATERCOLOR

ADELE EARNSHAW

NORTH LIGHT BOOKS

CINCINNATI, OHIO

www.artistsnetwork.com

about the Author

A sixth generation New Zealander, Adele Earnshaw was born in Hastings, New Zealand. Later the family moved to Warkworth, and finally, the United States. Her rural Warkworth home, surrounded by native bush, overlooked an estuary of the Mahurangi River. Growing up in this environment has had a major and lasting influence on Adele's work and choice of subject matter.

Adele's paintings have been exhibited at the American Museum of Natural History in New York, and have toured Japan and Sweden with Birds in Art exhibitions. She is a member of the Society of Animal Artists. Her native New Zealand selected her to design the first three stamps for the Game Bird Habitat Stamp Programme, which was based on the U.S. Federal Duck Stamp Program. She was invited to participate in the first Ecoart conference and exhibition in Taiwan. Her work, along with the work of twelve other artists representing nine different countries, was exhibited at the National Museum of History in Taipei. In recent years she has also been painting landscapes in oil, plein air.

Other than one beginning watercolor class, Adele is self-taught. She believes that with desire, tenacity, effort and discipline, almost anybody can become an artist. Her son, Shane Rebenschied, an illustrator, follows in her footsteps.

Adele teaches several watercolor workshops a year. For information on her workshops, go to www.AdeleEarnshaw.com.

Photo: Wayne Ferguson

Metric Conversion Chart

to convert	to	multiply by
Inches	Centimeters	2.54
Centimeters	Inches	0.4
Feet	Centimeters	30.5
Centimeters	Feet	0.03
Yards	Meters	0.9
Meters	Yards	1.1
Sq. Inches	Sq. Centimeters	6.45
Sq. Centimeters	Sq. Inches	0.16
Sq. Feet	Sq. Meters	0.09
Sq. Meters	Sq. Feet	10.8
Sq. Yards	Sq. Meters	0.8
Sq. Meters	Sq. Yards	1.2
Pounds	Kilograms	0.45
Kilograms	Pounds	2.2
Ounces	Grams	28.4
Grams	Ounces	0.04

Painting the Things You Love in Watercolor. Copyright © 2002 by Adele Earnshaw. Manufactured in China. All rights reserved. No part of this book may be reproduced in any form or by any electronic or mechanical means including information storage and retrieval systems without permission in writing from the publisher, except by a reviewer, who may quote brief passages in a review. Published by North Light Books, an imprint of F&W Publications, Inc., 4700 East Galbraith Road, Cincinnati, Ohio 45236. (800) 289-0963. First edition.

Other fine North Light Books are available from your local bookstore, art supply store or direct from the publisher.

06 05 04 03 02 5 4 3 2 1

Library of Congress Cataloging-in-Publication Data
Earnshaw, Adele.
 Painting the things you love in watercolor / by Adele Earnshaw.—1st ed.
 p. cm.
 Includes index.
 ISBN 1-58180-181-5 (alk. paper)
 1. Watercolor painting—Technique. I. Title.

ND2420 .E23 2002
751.42'2—dc21 2002022157

Edited by Jennifer Lepore Kardux
Designed by Wendy Dunning
Interior production by Lisa Holstein
Production coordinated by John Peavler

Acknowledgments

With thanks to:

My friend, fellow artist and North Light author, Joe Garcia, who introduced me to watercolor many years ago, then patiently listened to yet another rendition of the same paragraph in the writing of this book.

With gratitude to Wayne and Berta Ferguson, Anne Garcia, Bev Kephart and Carol Watters for their assistance.

Thank you to Rachel Wolf for approaching me to do this book; and to a very patient editor, Jennifer Lepore Kardux.

And finally, my thanks to a few that said I could never be an artist. Their doubts gave me the energy to work a little harder to reach my goal.

Dedication

This book is dedicated to my parents:
My mother, Julie Earnshaw, who didn't live to see me become an artist; and my father, Lester Earnshaw, who helped me get there.

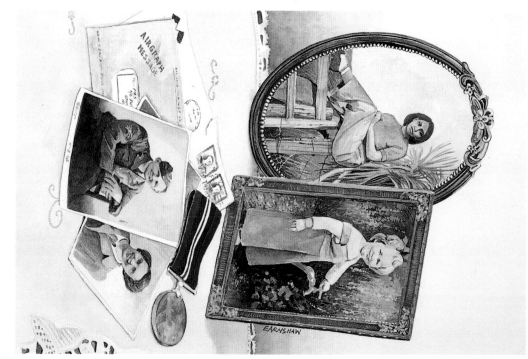

Olivia
Watercolor on 300-lb (640gsm) cold-pressed paper
12" x 8" (30cm x 20cm)
Collection of Lester Earnshaw

Table of contents

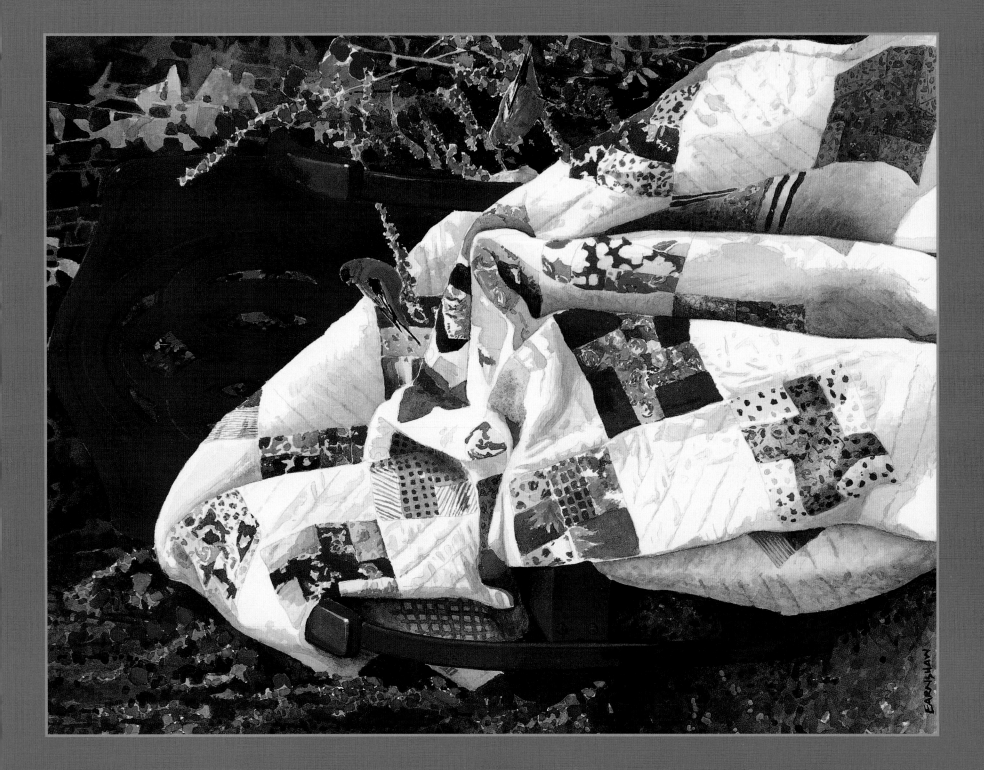

Introduction:
Attitude is Everything!

I was saved from an ordinary life when at the age of twenty-five I enrolled in a beginning watercolor class. Though I had dabbled in crafts, I had never tried painting. I was intimidated by art. It took God-given talent; I was sure I had none. But I made the happy discovery that obvious talent is not a requirement to become an artist. Certainly, Da Vinci and Michelangelo had great talent. But artists of lesser talent become successful because they have three necessary ingredients: DESIRE, EFFORT and TENACITY. The most important thing I learned in the class was that if I applied myself, I could become an artist. It's a simple equation: desire + effort + tenacity = artist. There is no magic.

However, this equation will fall apart without DISCIPLINE. Keeping regular work hours and learning how to say no to things that interfered with my workday were the most difficult lessons I had to learn. I am the hardest boss I've ever worked for.

Desire, effort, tenacity and discipline; the only thing stopping you from becoming a successful artist now is TIME and ATTITUDE. Negativity is the curse of the desire + effort + tenacity recipe. Don't look at your work too critically. Each painting is a stepping stone. If you paint a disaster and throw it away, you have learned from another mistake. But don't throw the rejects away. I've got a magic cupboard where my rejects are stashed. Once or twice a year I go through the paintings and miraculously, most of them look just fine after six months in the cupboard.

Don't be intimidated by CREATIVITY. The mystique that surrounds this word keeps many talented people from attempting to paint. But most of us have what it takes. As your ability to paint evolves, search for your own voice, a style of painting that is individually yours. Not only will this make your work stand out from the rest but it will also give you CREDIBILITY.

My evolution as an artist has been fueled by the desire to produce credible work that has my own style. At first I painted birds in natural habitat, but those paintings looked like the work of other artists. It was then I realized that to achieve a unique look to your art, subject matter is as important as style.

One day I hung a quilt outside to air. From my window I watched as a bird landed on the quilt. Bingo! I had the idea for a unique subject. I found I could create more unique compositions using man-made objects. My birds left their wooded habitat and found themselves on roofs, windows and statues, on my quilts and among my old teacups. These paintings have stories behind them and I am painting the things that I love.

Gather your favorite subjects around you and discover how to touch your viewers' hearts with paintings that tell a story and are uniquely your own.

Summer Gold
Watercolor on 300-lb. (640gsm) cold-pressed paper
16" × 13" (41cm × 33cm)
Collection of Angela Schwarzkopf

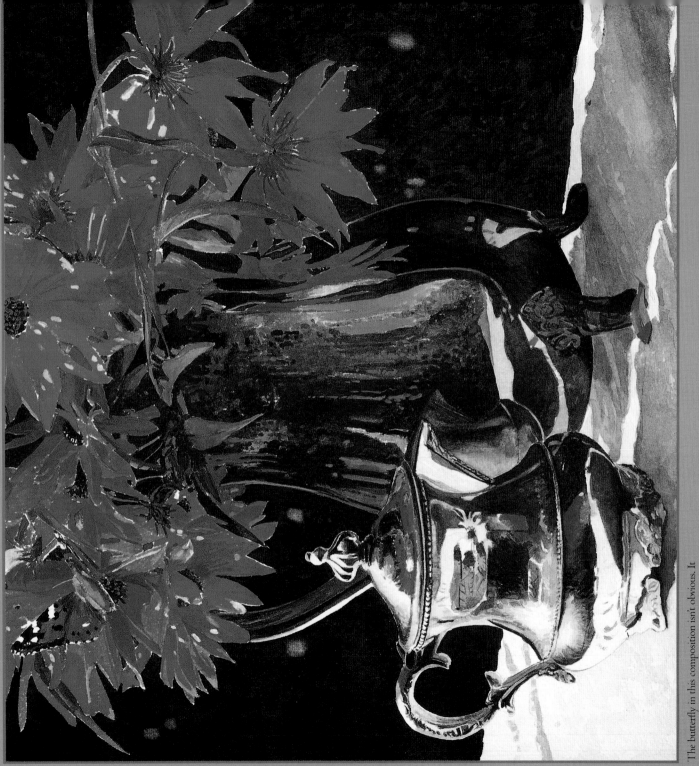

The butterfly in this composition isn't obvious. It comes as a surprise when the viewer spots it.

CHAPTER ONE

The Right Stuff: *Materials*

I think every artist has a natural way of painting that—with the right combination of paper, paint and brushes—will come with less struggle. I made a great leap forward when I started to experiment with materials. My old palette included Sap Green, Burnt Sienna, Yellow Ochre and Sepia. It had a dated look that reminds me of avocado green refrigerators from the sixties. I eliminated the opaques, added transparent colors, and switched from 140-lb. to 300-lb. (300gsm to 640gsm) paper. Somewhere in the huge selection of materials is the perfect combination of paper, color and brushes for you. If you don't look, you won't find.

Paints

Using transparent colors eliminates a lot of muddy mistakes. Transparent watercolor will give your paintings a sparkle, particularly if you want to paint the illusion of sunlight and shadow. But the extra punch comes from using the white paper for your lightest value.

I am not a purist. I admit to using opaques, selectively. If my subject matter is sunlit, I work transparently. If the subject matter is not sunlit, I may use opaques. *Summer Gold* (page 8) is painted with a combination of transparent and opaque watercolor. The quilt is strictly transparent. The chair and background are partly opaque. When I paint opaquely, I mix white (Dr. Martin's Bleed-Proof White) with transparent colors.

My Colors

Lightfastness and transparency vary by manufacturer, so I have listed brand names with my colors below.

Palette

I like to use a Pike palette. It is made of heavy white plastic, with a snap-on lid.

Raw Sienna
Da Vinci,
semi-transparent

Aureolin
Winsor & Newton,
transparent

New Gamboge
Daler Rowney,
semi-transparent

Quinacridone Gold
Daniel Smith,
transparent

Quinacridone Sienna
Daniel Smith,
transparent

Permanent Rose
Winsor & Newton,
transparent

Rose Madder Genuine
Winsor & Newton,
transparent

Spectrum Red
Winsor & Newton,
opaque gouache

Permanent Alizarin Crimson
Winsor & Newton,
transparent

French Ultramarine Blue
Winsor & Newton,
transparent

Winsor Blue
Winsor & Newton,
transparent

Cobalt Blue
Winsor & Newton,
transparent

Manganese Blue
Holbein,
semi-transparent

Winsor Green
Winsor & Newton,
transparent

Viridian Green
Da Vinci,
transparent

Build Up Your Colors

Working from the lightest to darkest value, I often underpaint everything that I've not selected to remain the white of the paper, with a unifying wash. Allowing the paper to dry between washes and working quickly so that I don't lift underlying color, I build up layers of either individual color or combinations, until I reach my darkest value.

A combination of Permanent Rose and Cobalt Blue is used here, varying the ratio of blue to rose, over a dry wash of Permanent Rose-Raw Sienna. The transparency of the Permanent Rose-Cobalt Blue wash allows the glow of the first wash to shine through. Some of this Permanent Rose-Cobalt Blue has been applied not as a wash, but as dry brush, especially on the bodice. Adding a little Manganese Blue to the mixture will cause the colors to granulate—a great texture for stone.

The mixture of Winsor Blue and Alizarin Crimson makes a colorful, transparent dark.

Mix the darkest darks using Winsor Green and Alizarin Crimson. For a warmer dark, try adding French Ultramarine Blue to this mixture.

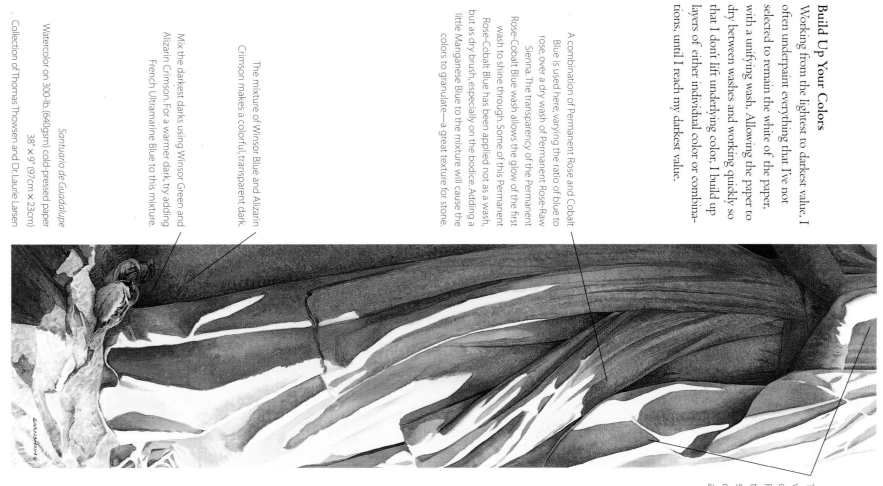

Santuario de Guadalupe
Watercolor on 300-lb. (640gsm) cold-pressed paper
38" × 9" (97cm × 23cm)
. Collection of Thomas Thowsen and Dr. Laurie Larsen

The first and lightest wash is a combination of Permanent Rose and Raw Sienna. This gives the statue a glow that shows through even the darkest values, unifying all areas of the statue.

Brushes

I use round brushes almost exclusively: Robert Simmons, white sable, series 785, no. 36, no. 14, no. 8, no. 4 and no. 2 rounds. White sable brushes hold their shape well, and because they are inexpensive, you won't feel quite as guilty when you relegate a worn brush to cleaning cat hair out of the computer keyboard.

I prefer to use round brushes, even when painting a big area, but when the area is really large, I sometimes use a 1-inch (25mm) flat brush, such as an Aquarelle.

Occasionally I use Fritch scrubbers, which are short-bristled brushes made specifically for lifting and scrubbing. These brushes aren't easy to find, but check with your local art suppliers. If they don't carry Fritch scrubbers, they may be able to order one for you. I found mine through Cheap Joe's Art Stuff art catalog, (800) 227-2788.

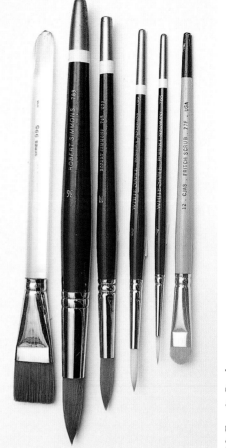

My Favorite Brushes
From top to bottom: 1-inch flat (25mm) Aquarelle; Robert Simmons White Sable, series 785, no. 36, no. 14, no. 8, no. 4 rounds (no. 2 not shown); Fritch scrubber.

What Shape Is Your Brush In?
Check your brush to see if it still holds a point. Wet the brush and tap the side of the handle sharply on a table edge. If the bristles form a straight point, the brush is still in good shape. The bristles of a worn-out brush will bend and separate.

Good brush

Old, worn-out brush

Make Your Own Water Containers

Use a large container for your water; a 1-gallon (3.8-liter) plastic bottle or one of the sturdy plastic bottles that kitty litter comes in. Leave the handle attached, and cut away the top and sides of the bottle.

Watercolor Paper

Buy the best paper, even if you can only buy one sheet. Like learning how to ski on 2X4s (rough wooden planks), it doesn't work to learn on cheap paper. No matter how good you are, student-grade paper has a way of making the painting look just that.

I use Arches 300-lb. (640gsm) cold-pressed watercolor paper. The thickness and texture work well with my glazing technique. The paper I use measures 22" × 30" (56cm × 76cm).

To Stretch or Not to Stretch?

The size of my bathtub has limited the size of my paintings. (I have wondered if the United States Internal Revenue Service would consider the addition of a lap pool as a tax deduction in order to soak large pieces of watercolor paper.)

Watercolor paper is larger when wet, and tightens as it dries. Soaking your paper, stapling it to a board then allowing it to dry, will give you a flat painting surface that remains tight during the painting process. I stretch because I don't like to battle the buckles of unstretched paper and I prefer the surface of stretched paper. It is softer and more absorbent.

Soak the Paper

Put four or five inches of cold water in the bathtub and submerge the paper. As the

paper floats to the surface, push it under the water several times during a 45-minute soaking. When the time is up, lift the paper out by two corners and hold it over the tub for a minute, allowing the extra water to run off. Then you're ready to staple it to a board (see below).

Why Paint on Dry Paper?

Control is the reason I work on dry paper. If the paper is dry, the paint will go only where you put it. But there is a trick to painting on

dry paper. Think of how you would ice a birthday cake: You put a big blob of icing on the cake then spread the icing to cover the rest of the cake before it starts to stiffen up. You work much the same way on dry paper. Put down some paint and keep your brush moving around the perimeter of wet paint. If a brushstroke sits too long on dry paper, it will form a hard edge that is difficult or impossible to remove. By painting quickly, this edge doesn't have time to dry.

Stapling the Paper to the Board

Put the wet, soaked paper on a board (a varnished piece of plywood works well), making sure the paper is flat. Use a staple gun to staple the paper to the board, stapling ½-inch (12mm) from the outside edge, every four inches all the way around the perimeter of the paper.

Let the paper dry completely, preferably overnight. Feel the paper with the back of your index finger. If the paper is room temperature, it's dry. If it feels cool, it's still damp.

Removing the Staples

Heavy staples are hard to remove. When your painting is complete, try sliding a flat-head screwdriver under the paper, under the staple. Then, carefully wiggle the screwdriver from side to side, lifting the staple from the board.

Workspace

Whether you have your own studio or a corner of the garage, you'll spend more time painting if you don't have to set your supplies up and put them away each time you paint. Even an ironing board makes a great painting table when space is limited. You—and others—will take yourself a little more seriously if you have decent studio space.

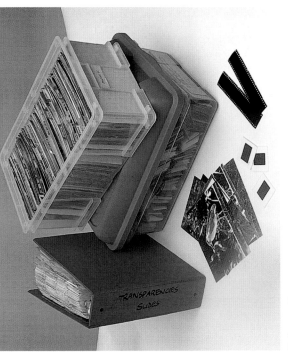

Reference Storage

Don't waste painting time searching through your reference material. Organize it! If you use photographic reference, you should use only photographs you have taken or have the right to use. Flowers, birds, quilts, etc. can be separated and organized into species or type.

Slides or photos? Slides take up less storage space and have better color, but I prefer using 5" × 7" (13cm × 18cm) photos for reference because I can cut and tape as you will see in chapter three (page 34). In addition, as I live in an area subject to forest fires, the negatives, which I keep in another location, serve as a backup reference file.

The plastic containers pictured here are easy to find, available in various sizes and come with lids. Some are stackable. Use index cards with tabs, labeled with the appropriate categories, to organize your photographs.

Lighting

Ideally, you need a large, flat table, a comfortable chair, and good lighting. North light isn't always possible. Fluorescent shop lights with both warm and cool bulbs are an inexpensive alternative when supplemented with a combination incandescent-fluorescent lamp clamped to your work table.

Make Use of a Slide Table

A slide table can be used for more than viewing and taping slides. Use the table to trace drawings and to view photographs. The backlighting will allow you to see much more in the darks of a photo.

Other Equipment

A few other items to gather and you're all set to get started painting!

Handy Supplies

Keep these other supplies on hand: white artist's tape; Pelican Graphic White (you can substitute Dr. Martin's Bleed-Proof White); carpenter's square; ruler; proportional scale; scissors; mirror; paper towels; small spray bottle; craft knife; single-edged razor blade; fine sandpaper cut into 2-inch (51mm) squares; kneaded eraser.

Fit Your Drawing Onto Your Paper

How many times have you run out of paper before you've finished your drawing? A proportional scale will give you the exact dimensions of your painting before you've even started the drawing. First, measure the image size of your reference photo. Let's pretend your reference photo is 3" × 4½" (8cm × 11cm). Now move the center ring of the scale until the 3 is lined up with a number on the outer ring. When 3 is lined up with 12, then 4½ is now lined up with 18. So you know that your 3" × 4½" (8cm × 11cm) reference will fit perfectly on 12" × 18" (30cm × 46cm) paper! You can find a proportional scale at an office or art supply store.

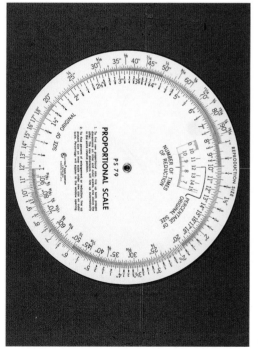

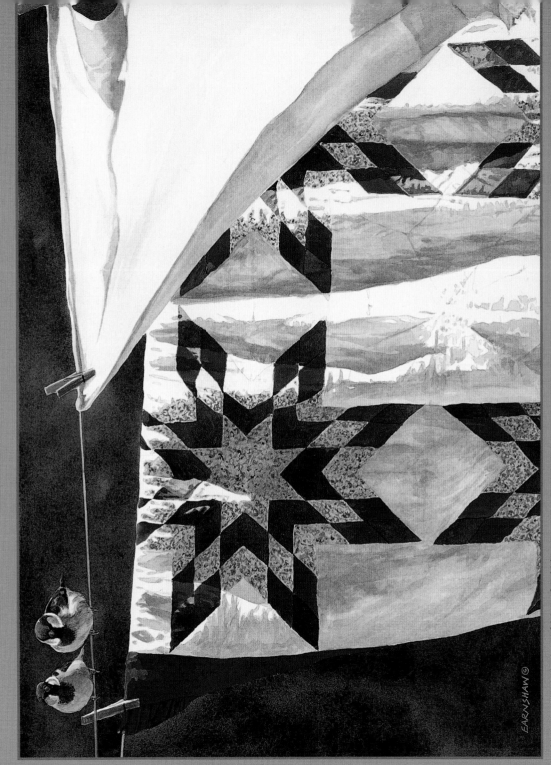

EARNSHAW ©

Addie Mayou made this beautiful Star of Bethlehem
quilt sixty years ago. Using fabric scraps and worn-out
clothing, generations of women have recorded their
family histories in quilts.

CHAPTER TWO

Exploring the
Subjects You Love

Before we discover our individual style and subject matter, we all face a common dilemma: What can I paint? After a while barns and trees lose our interest. In this chapter, I'll give you some ideas on how to use storytelling, nostalgia and documentation to create paintings that not only are fun, but will appeal to others.

Part of the fun of painting the things you love is the hunt for props. Search antique shops, borrow bits and pieces from friends, and use your own treasures over and over again.

Sometimes the very best subject matter is right under your nose. Open your children's toy box and take a bird's-eye photo of the contents. You don't need to paint the entire toy box. Just paint the jumble of toys. Now isn't this more exciting than painting a barn? Paint a section of the workbench in the garage, paint the inside of your china cabinet. How about the pile of shoes on the floor of your daughter's closet? Don't try to paint it all. Crop in! Just show what you are talking about: a pair of sneakers, soccer shoes, fluffy bedroom slippers and ballet shoes. These innovative and original paintings are not only more fun to create, they're a lot more interesting to look at. You'll start seeing things a little differently. *Everything* becomes potential subject matter!

Telling a Story

There are different ways of telling a visual story. Norman Rockwell's work comes to mind. One of his paintings illustrates a young boy discovering a Santa Claus suit in the dresser of his parents' bedroom. There is a look of astonishment on his face. Rockwell's story is obvious. Howard Terpning's work is what makes it so appealing.

The story you tell in your painting does not need to be historic, sentimental or even true. Inventing a story is part of the fun, but a painting that tells a true story is compelling.

work is another example. His paintings of the early American West are known for their historical accuracy. His work is a documentation of that era. Andrew Wyeth's *Christina's World* tells a story, but leaves much to the viewer's interpretation. And why is Mona Lisa smiling? The intrigue of this type of

A Title Can Relay Humor
The viewer doesn't need to read the title to get the message, but the title adds a little humor.

You Snooze, You Lose
Watercolor on 300-lb. (640gsm) cold-pressed paper
13" × 28" (33cm × 71cm)
Private collection

Selling Your "Story"

There are dozens of different ways to tell a story with your painting. But if selling your work is a priority, art buyers aren't interested in buying a painting that tells the history of your family. The painting becomes saleable if you keep the subject matter a little generic, avoiding reference to a specific person or family.

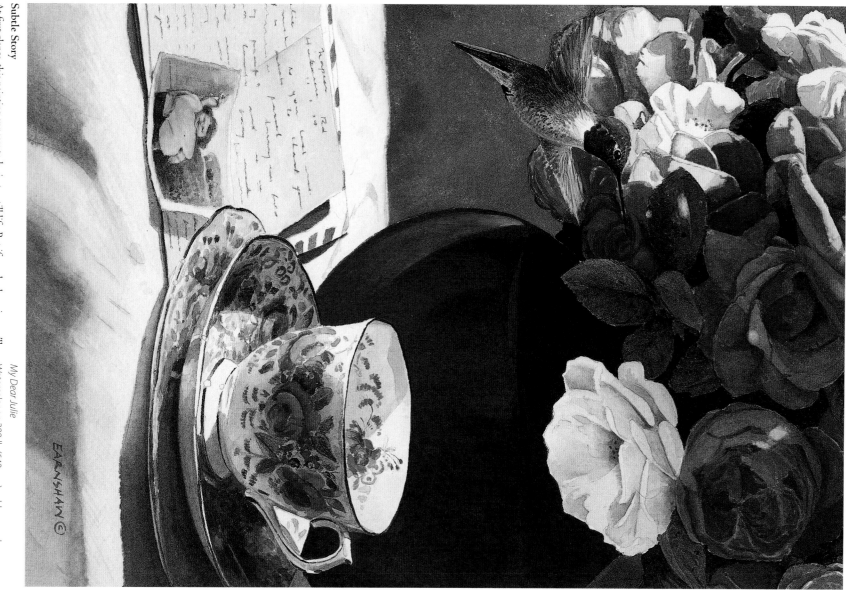

EARNSHAW ©

Subtle Story

At first glance, this painting appears to be just a still life. But if you look again, you'll see the letter and photograph. A letter from home? A good story doesn't need to supply all the details for the reader—or in this case, the viewer—to understand the story. It's often better to leave just a few clues and let the viewer think about it.

My Dear Julie
Watercolor on 300-lb. (640gsm) cold-pressed paper
12" x 8" (30cm x 20cm)
Collection of Catherine and David Plocki

Nostalgia

I'm the custodian of my family archives. I'm sentimentally attached to all the old stuff that tells the history of my family. Old china, photographs, letters and wedding gowns are in almost every family's history. You may have everything you need for several paintings in your attic, closets and china cabinet.

Some things make us think of home. Not just any house, but the warm and cozy home of our childhood. Maybe this is why a quilt gives us a warm fuzzy feeling. Your painting will have more appeal if you include a few things that pull on the heartstrings. Was your quilt stitched in the evening by lantern light? Perhaps your painting could include a lantern casting a warm glow with a pair of sewing scissors and pincushion next to it. Add a cup of tea, using a vintage teacup, next to the lantern and you create the feeling that the woman stitching the quilt has just stepped out of the image.

Painting your own special treasures is a way of documenting what is important to you or others. The sentiment adds another element of interest to what could be an ordinary picture and makes the painting part more pleasurable. And the painting is more likely to work when you know the subject well and enjoy painting it. Many art buyers also appreciate this approach. When I show a painting for the first time, I watch for the reaction of those viewing it. If they smile, I know the painting is a success.

Childhood Memories
We all had a spinning top in the toy box. Using an odd number of tops, I used the shadows to unify the tops into a long horizontal shape.

Tops
Watercolor on 300-lb. (640gsm) cold-pressed paper
8" × 29" (20cm × 74cm)
Private collection

Feelings of Home
Flowers are a powerful reminder of the past. I began painting hollyhocks because they grew in my garden when I was a little girl. I soon discovered that other people loved them for the same reason. Who doesn't remember making ballerinas out of hollyhock flowers? Sweet peas, pansies, foxglove and snapdragons are also old-fashioned flowers. A flower that reminds us of home is bound to evoke a sentimental response.

Hollyhocks
Watercolor on 300-lb. (640gsm) cold-pressed paper
9" × 11" (23cm × 28cm)
Collection of the artist

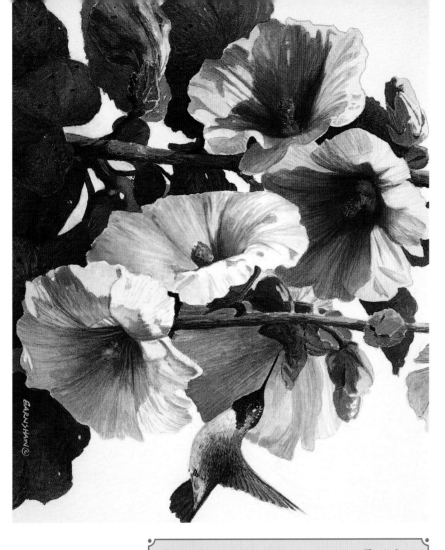

Setting the Mood

When you're deciding what to paint, don't forget that light is as important as the objects you are painting. Using lantern light as your only light source in a painting adds to the story and creates drama. A table setting incorporating a bird or butterfly, or a quilt on a clothesline, must use natural sunlight if you want your outdoor setting to be believable. Soft diffused light filtered through curtains, backlighting, strong sidelighting and cast shadows add to the mood of the painting and give compositional structure.

Documentation

Before photography, explorers such as Lewis and Clark hired artists to accompany them. The paintings completed on the trip served as a visual record of the things seen and discovered.

You can document in the same way and have fun coming up with ideas and themes. How about a row of your baby's shoes or your grandfather's service medals and letters home? Document your children as they grow. Paint a visual record of ancestral gravestones. Record the memory of a wedding with a painting of the bridal bouquet. I have an artist friend who is busily painting landscapes, documenting the county he lives in before it succumbs to the developer's bulldozer.

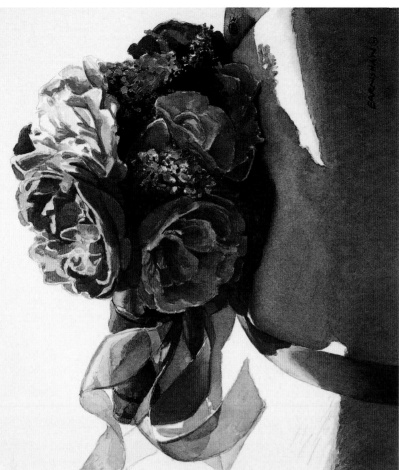

Special Events
A realistic painting is a good way to document, or remember a special bouquet. The ladybug in this painting adds a little surprise.

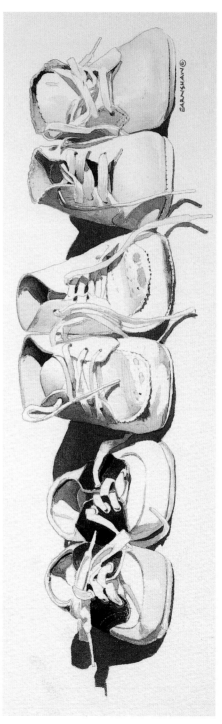

Life Changes
Nothing more is needed in this painting. The shoes tell the entire story, documenting a time in a child's life and the feeling of being a parent. The shadows help to define the white shoes against the white paper.

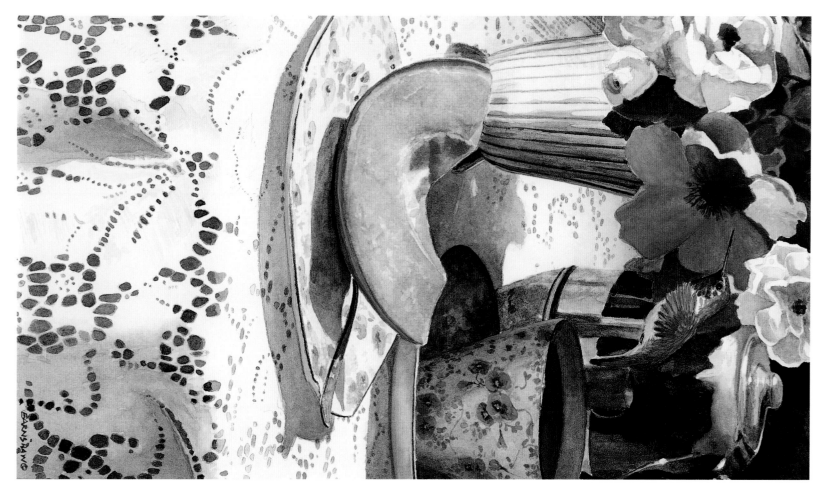

Well-Loved Objects
What better way to document and preserve a special
teacup than to paint it?

The Breakfast Guest
Watercolor on 300-lb. (640gsm) cold-pressed paper
12" × 8" (30cm × 20cm)
Private collection

The Importance of a Title

A good painting deserves a little effort spent on finding the right title. A title can help get your idea across or can complete the story. Sometimes, a title sells the painting. Look for one that is not too trite or cute. I refer to a dictionary of clichés or a thesaurus to come up with just the right one. Sometimes, I think of the title first, then plan a painting to suit it!

Give a New Twist

This small painting of cows and a barn became whimsical when I titled it *Till the Cows Come Home*. Had I named it *Summer Afternoon*, the painting would have lost some of its appeal.

Till the Cows Come Home
Watercolor on 300-lb. (640gsm) cold-pressed paper
2" × 9" (5cm × 23cm)
Private collection

Portray Deep Meaning

After completing this painting, I realized the angel appeared to be watching over the young sparrow perched on her trumpet. But this was not the story I wanted to tell. The title, *Heart of Stone*, explains my point of view. Though it appears that the angel is looking out for the young sparrow, she is only a statue. The title tells the viewer that the sparrow is on its own in the big world, making the painting a little more poignant.

Heart of Stone
Watercolor on 300-lb. (640gsm) cold-pressed paper
26" × 17" (66cm × 43cm)
Collection of Timothy J. Savage

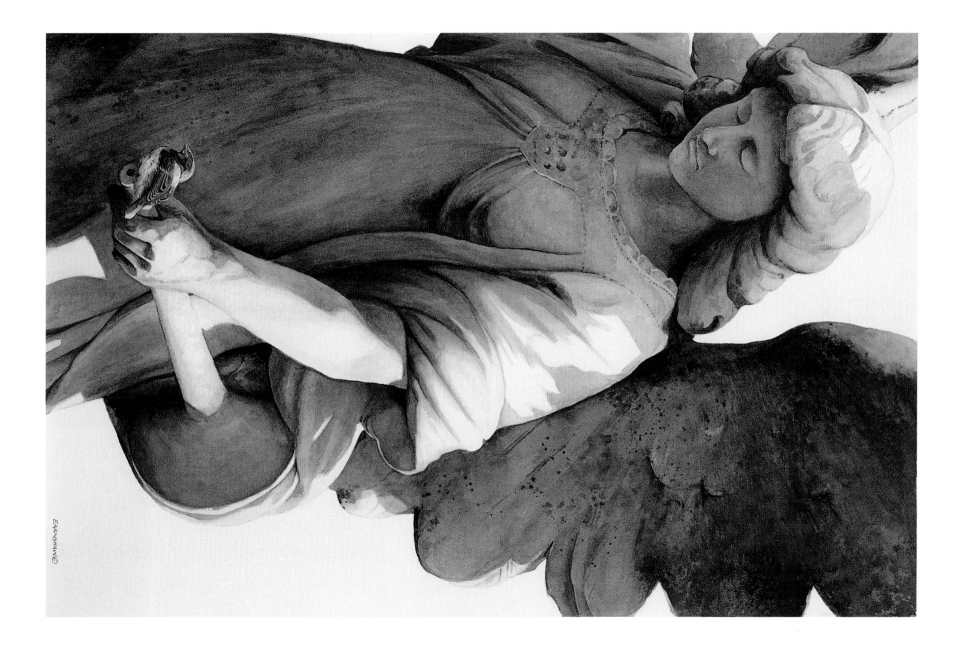

I often base my composition on a repetitive pattern, which I interrupt with a focal point. In this painting the lanterns serve as the repetitive pattern. The birds break the repetition. I cropped some of the lanterns to suggest that there are many more.

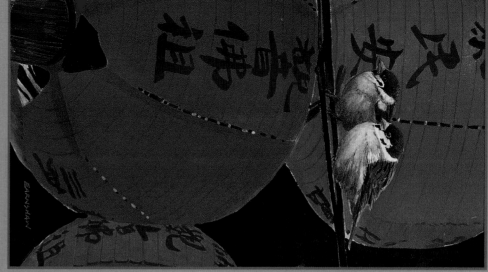

Planning Your *Composition*

Don't be intimidated by the word *composition*. Think of it as *design*. Composition is simply the arrangement of the parts of your design, but it makes the difference between a boring painting and an interesting one. There are rules of composition, but as a self-taught artist, I don't consciously follow them. My compositions are instinctive. Most of you already have a sense of balance and design that you must learn to trust. Initially we spend most of our time learning how to handle the brushes and paint, and little time on composition. Remember that a well-rendered painting will fall flat if the composition is weak. On the other hand, a well-composed painting will work even if it's painted with shoe polish. In this chapter I'll share with you the tools and tricks I use to create a good composition.

Tree Sparrows at Dragon Mountain
Watercolor on 300-lb. (640gsm) cold pressed paper
13" x 28" (33cm x 71cm)
Collection of Joe and Alice Smith

Photographing Your Subject

Photo References

Photo references can be used to find and capture the right subject for your painting. They snap a moment in time, helping you remember important details like lighting and shadow.

For a small annual fee you can download photographs from the Internet with few copyright restrictions. But, keep in mind that other artists can also use the same reference material.

If you choose to work from photographs, make sure they are either your own or that you have the right to use them. Taking your own photographs will help your work develop an individual look. If you ask five artists to photograph the same subject matter, you'll end up with five different views of the same object.

Camera and Lens

I like to zoom in on my subject, and find that a 35mm camera with a 60-300mm zoom lens works best for my close-up shots. While standing in one place I can zoom out to take a full shot of the subject matter, then zoom in for closeups that will give me detail. I use a 50mm lens for taking shots of my paintings.

Slides, Prints or Digital?

I like to use 5" × 7" (13cm × 18cm) glossy prints. It's too expensive to have 5" × 7" (13cm × 18cm) prints made from your negatives. Look around for a photo processor that will develop your film directly as 5" × 7" (13cm × 18cm) prints. I have my film developed this way for less than $7 a roll.

Color prints can be cut up and taped together to help determine a composition or subject. The negatives can be stored in a safe place as a backup reference file in the event of fire, etc.

Slides allow for better color and detail. Storage is easy, but viewing can be difficult. Slide processing costs about $8 for 36 exposures. You can flip images easily with a slide to help put together a composition.

A digital camera and computer require considerable financial investment and become outdated every few years. But if you are computer literate and prepared to invest the money on equipment and software, digital is quite convenient. You can enlarge detail, flip, print in color or black and white, and store thousands of images on a few discs. Though you'll have no costs for film developing you will have the expense of photographic paper and ink. You can also use a scanner to get your traditional photographs into the computer to enlarge detail, flip, and play with the color.

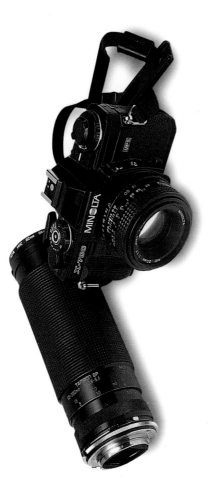

35mm camera and 60-300mm lens.

Sunlight is a Must

If you plan to photograph your subject, it is best to do so on a sunny day; as the shapes of light and shadow are an important part of composition. If you photograph before 10:30AM and after 2:30PM the light and cast shadows will be longer and more dramatic.

Lacking Light and Shadow
This photo was taken on an overcast day so there are no shadows to give depth and show the movement of the quilt.

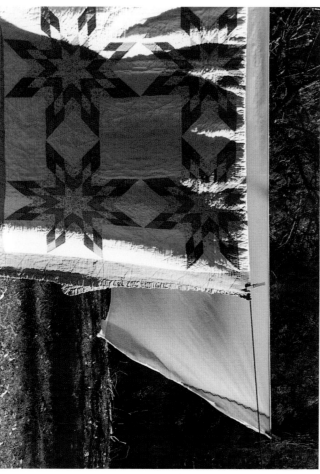

Perfect Contrast!
When a quilt is gathered, the surface is no longer flat. When the sun is to the side, the folds cast interesting shadows on the sunlit quilt. Sometimes I use an electric fan to create movement in the quilt if there is no wind.

Lacking Contrast
The sun is out but the quilt is hanging flat, with no folds to cast shadows.

Using Your Viewfinder

A painting starts with an idea. The idea may come from something you see, or the idea might come long before you find your subject matter. Either way, using a viewfinder to find your subject can be a big help. The enormity of what you are viewing—for example, a landscape—can be overwhelming. Viewing your subject through a viewfinder, such as the lens of a camera or a slide holder with the film removed, will help bring your subject into focus.

Finding Your Subject

Using a slide holder allows you to focus on just a part of the entire landscape. Hold it closer to your eye to enlarge the image; hold it further away to make the image smaller. Move the slide holder until you find a pleasing image, looking for awkward lines or shapes that feel uncomfortable. Avoid the obvious, such as a line that leaves the image at a corner, a shape that ends at the very edge of your slide holder or a line or shape that divides your design evenly in two, either horizontally or vertically.

Zoom In

Look through your camera's viewfinder. Imagine trying to paint what you see. It helps to think of this when taking photos. When photographing (let's use a table setting as an example), zoom in and take a series of photographs, scanning the objects on the table.

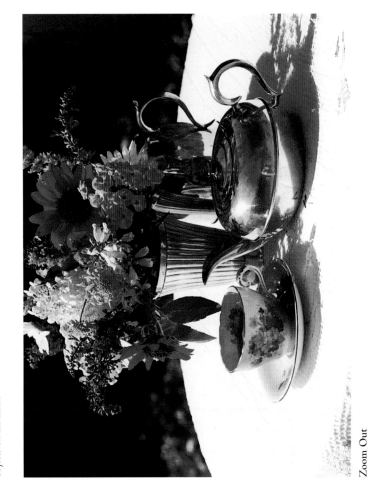

Zoom Out

Then step back and take a few shots of the entire table setting. You can use these photos to fill in the gaps if you happen to miss something in the closeups. Take more photographs than you think you will need. The more you take, the more likely you are to get photographs that will work for your painting.

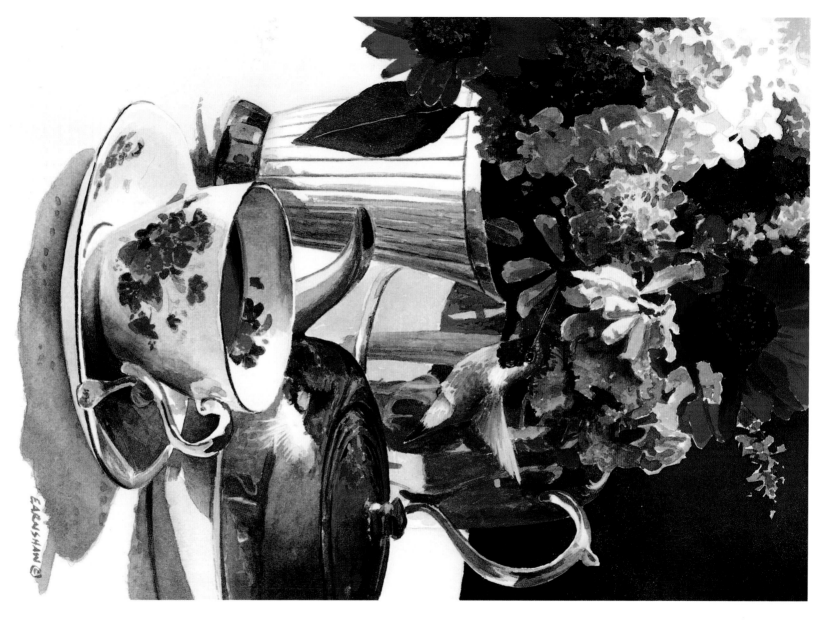

Working With Multiple Photographs

As you are photographing your references, take a series of shots from the same vantage point, rearranging your subject matter gradually. Take a series of close-up shots, scanning the subject matter. This will allow you to capture the details of your subject.

Have prints made and look through the various shots, mixing and matching different prints like a mosaic until you find an arrangement that works for you; then tape them all together. If you need to add an element, look through other references for birds, flowers or whatever you wish to incorporate into your painting. Add these elements when you do your drawing.

Be Aware of Scale

If you're painting a bird on a clothesline, use a clothespin to check the scale of the bird. A bird field guide will give you the length of the bird you are painting. Compare it to the length of the clothespin.

Gather Images
Take many photos. Some might work as references for a good pose, while others could be used as lighting references. You can even use your sketches from life as references.

Make a Composite
Arrange the photographs until you find a pleasing composite. Tape the photos together. Cut a mat in two at opposite corners so that you can make the mat window larger or smaller. Move the mat around the composite, looking for a pleasing composition. Use white artist's tape to mark the final image you select.

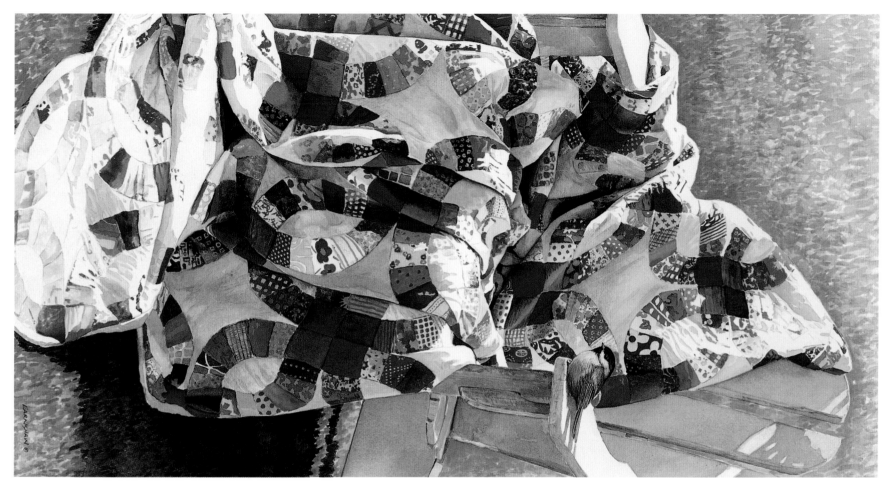

Combine Your Reference Photos

When I took the photographs for *Something Old, Something New*, I shot the first roll of film, rearranging only the bottom part of the quilt in each shot. Then I took another roll of film, left the bottom part of the quilt alone and this time I rearranged the upper part of the quilt. Then I mixed and matched the top and bottom halves of the quilt until I had the perfect arrangement (see facing page).

Although this painting is a result of photographic reference there is really no photograph that looks exactly like the painting. The chickadee was added from another reference. The title tells a story. "Something old" refers to the antique wedding ring quilt, but "something new." It encourages the viewer to spend a little longer looking at the image.

Something Old, Something New
Watercolor on 300-lb. (640gsm) cold-pressed paper
25" × 13" (64cm × 33cm)
Collection of Timothy J. Savage

Cropping

I fought with backgrounds for a long time before I discovered the obvious: leave them out! Zoom in on the subject and eliminate the background. This will simplify and strengthen your composition and can give your work an innovative look.

Cropping can also create dynamic formats: long and narrow or even square shapes. How about round or oval? Cropping can provide exciting negative spaces and can also eliminate uncomfortable negative shapes. Don't restrict yourself. Be innovative!

Once you get used to using your mat corners as an aid to cropping and looking for compositions within your reference, you'll find that some of the nicest designs are long narrow images. This shape, either horizontal or vertical, gets rid of the unnecessary, forcing the viewer to focus on what you're really talking about. It works particularly well with repetitive formats. The length of the composition gives enough space to show repetition. If you're used to working in standard sizes, it's invigorating to realize you can go beyond the boundaries.

Define Space

This painting is almost square. I cropped into the statue to create interesting negative shapes. Instead of a background, I left the paper unpainted.

All God's Children
Watercolor on 300-lb. (640gsm) cold-pressed paper
24" × 23" (61cm × 58cm)
Collection of Thomas Thowsen and Dr. Laurie Larsen

Cropping in on this image made this composition unusual and interesting.

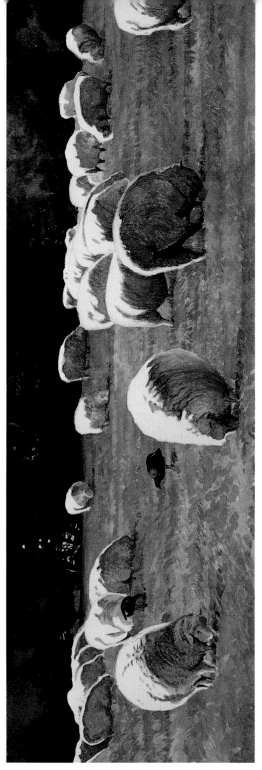

Waikato Morning
Watercolor on 300-lb. (640gsm) cold-pressed paper
9" × 32" (23cm × 81cm)
Private collection

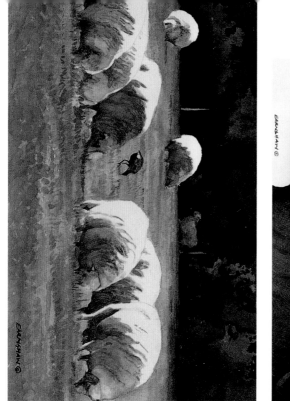

Narrow Focus

The long narrow shape of *Waikato Morning* forces the viewer to focus on the sheep. The length of the painting allowed me to show enough sheep so that they become a repetitive pattern, broken only by the pukeko, a species of swamp hen.

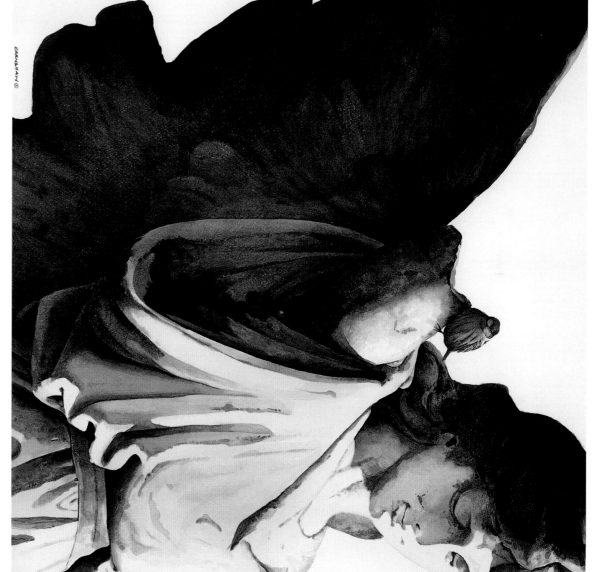

Using Light and Shadow

When I first started to paint, my watercolor teacher taught me to squint. I spent the next six months seeing the world through half-closed eyes, amazed at what I had been missing with eyes wide open. Everything was reduced to lights and darks, simplifying confusing detail into mass. Now, light and shadow have become important components of my paintings. But whether you use candle-light or sunshine, the shapes created by light and shadow can be used to create powerful compositions.

The light shapes within a painting can unify or disrupt a composition. Light shapes attract the eye. By placing these shapes purposefully you can control the way the eye moves around the painting.

Don't forget that you can change the shape of the light areas you see by darkening or eliminating them to enhance your composition. Dark shapes, such as shadows, can be used in the same way as light shapes. Cast shadows can be as or more important than the object casting the shadow. For example, when shown under low-morning or late-afternoon light, an ordinary tree can be transformed with a long shadow stretching across the sidewalk, down the curb and into the street.

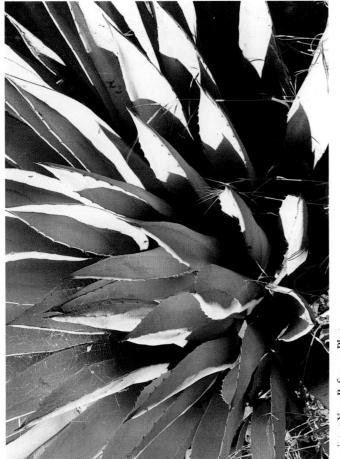

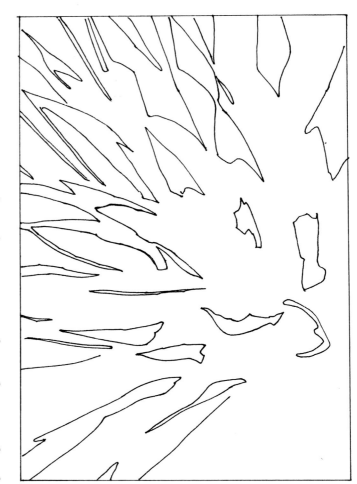

Squint at Your Reference Photo
Look at this reference photo through half-closed eyes. Forget for a minute that the subject is an agave, and look only at the shapes and pattern of light. Light or dark shapes are an effective way of moving the eye around a painting. Consider using these shapes as the foundation for your composition.

Trace the Light Shapes
If it helps you to see the patterns of light, trace only the light shapes in your reference photo, then look at the composition formed by these shapes. Is it interesting? Are any of these shapes awkward? Make changes, eliminating or simplifying shapes; then incorporate the changes into your final drawing.

Finding the Lights in Your Photos

It is easier to see the shapes and patterns of light in a reference photo if you hold the backside of the photo to a light, or put several sheets of tracing paper over the photograph. Do this when you are selecting a reference and deciding where to crop it. Look for a pleasing arrangement of light that flows through the image.

Rework the Lights and Darks

You can see how much of the reference material I eliminated (see facing page). As soon as I traced the light areas, I realized the painting would be far too busy. I eliminated much of the light by cropping into the image. A few of the remaining sunlit areas were awkward so I darkened the value, putting them in shadow.

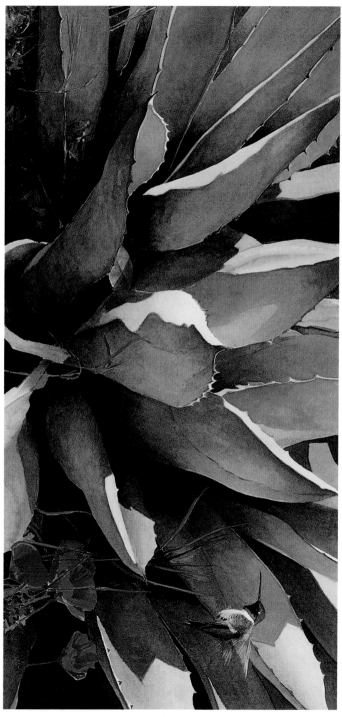

Arizona Morning
Watercolor on 300-lb. (640gsm) cold-pressed paper
12" × 24" (30cm × 61cm)
Private collection

Creating Good Negative Shapes

Composition is the arrangement of shapes in your design. In addition to the positive shapes of your subject, there are also negative shapes to consider. These are the shapes that surround your subject. I consider the negative shapes more important than the positive shapes! Because negative shapes are often between the subject and the painting's outer edge, they can create uncomfortable visual shapes such as a long narrow rectangle running along the edge of the painting, or an empty triangle in a corner. Bad negatives may cause the eye to return to one spot again and again. If you find yourself with an ugly negative shape when you're well into the painting, try darkening the value of the shape a little to make it less conspicuous.

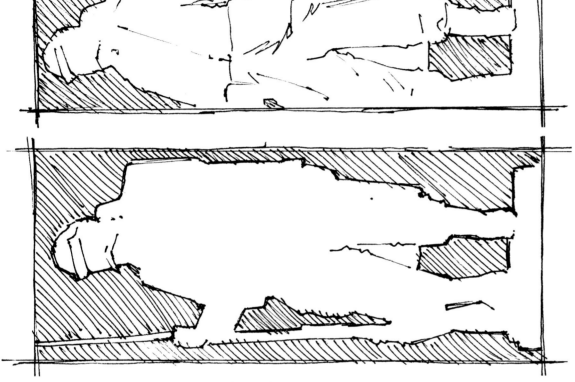

Bad Negative Shapes

I'd been fascinated with this statue since seeing it at a cemetery in Paris, but I knew it would be difficult to make an interesting composition. I wanted to show the entire statue, including the gun, but when I sketched it, I could see that the negative shapes on each side of the statue were stagnant spaces.

Good Negative Shapes

Here, I cropped into the soldier, eliminating the long negative shapes that almost outline the statue. This composition works better. Cropping simplifies the design by eliminating many of the negative spaces. The remaining negative shapes are more pleasing than those in the sketch at left.

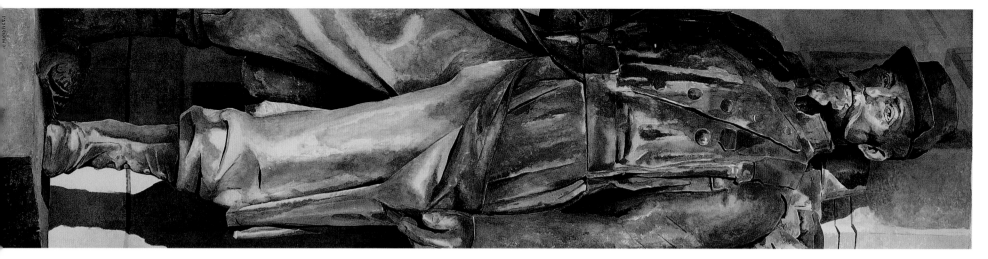

The Subject Stands Out From the Background

It took me longer to design *Reverie* than to paint it. At first I cropped into the body of the statue to eliminate the uninteresting negatives that paralleled the torso. I broke up the remaining negative shapes with cast shadows to make them more interesting.

Reverie
Watercolor on 300-lb (640gsm) cold-pressed paper
50" × 13" (127cm × 33cm)
Private collection

Overlapping Shapes

Unify objects within your composition by overlapping them. Think of the elements of your design as flat shapes. Vary the size and height of objects and the spacing between them. (Don't forget that the negative shapes are as important as the positive.) Forget that these shapes are, for example, a silver pot, a plate with melon and cast shadows.

Draw each shape from within your composition on separate pieces of tracing paper. Overlap the tracing paper and move the shapes around until you find a design that you like. This is where you work out the flaws of your design. For example, if the tip of a teapot spout visually touches the edge of a cup, this junction will feel uncomfortable. It is better to overlap objects or shadows than to have awkward spots where they barely touch edge to edge. Don't forget to look at what the cast shadows are touching. Reverse your design and look at it upside down. A good composition will work from all angles.

The silver pot is lined up directly behind the melon.

The edge of the cup meets the edge of the silver pot.

The melon edge lines up with the saucer rim.

The plate and saucer edges meet.

Awkward Setup

The mistakes in this design are easily avoided if you take a few minutes to look at each object and its relationship to other objects and shadows in the design. Notice that there is little overlapping here.

Good Setup

By slightly moving the melon plate up, the melon edge is now above the rim of the saucer. Moving the pot to the left has eliminated the junction where the teacup and silver pot touched. The pot also looks better to the left of the melon instead of directly above it. In this sketch, all three objects overlap, giving a sense of unity to the grouping.

Using Other Compositional Aids

I have a few other tricks that I use as I work on a painting.

Mirrors

Have you ever wondered what your work would look like to someone else? The closest you'll come to this is to view your work in a mirror. You'll be amazed how mistakes pop out when reversed in a mirror. Make a habit of checking the mirror image of your painting several times during the painting process.

You can also use a small mirror on your work table to reverse your photographic reference.

Photocopies and Scans

Strong, bright color makes it difficult to judge value. If your painting is not quite right, and you don't know why, photocopy it or scan it into your computer and convert it to black and white or halftone. Inaccurate values will show up immediately.

Please note that an ordinary black-and-white copier will be just black and white, with no shades of gray. You need to have a black-and-white copy made on a *color copier*. This will give you the halftone you need.

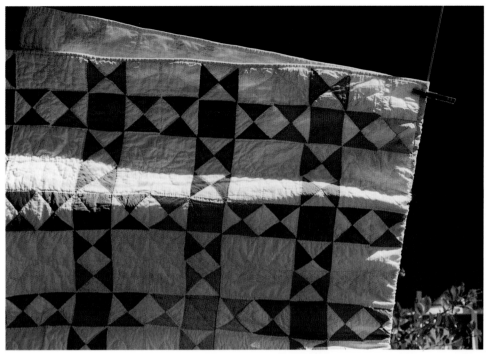

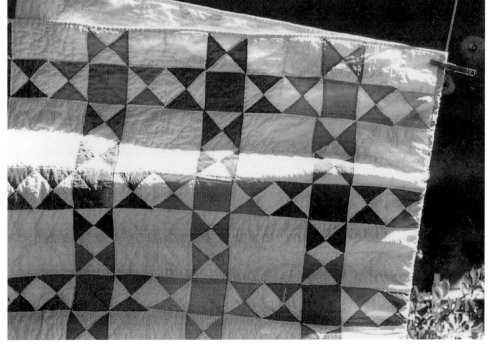

Confusing Values

Bright colors confuse values, particularly in quilts. The bright colors also make it difficult to understand the values of the folds.

Clear Values

Eliminate confusing colors by getting a black-and-white or halftone photocopy or scan of your reference. The values are much easier to see.

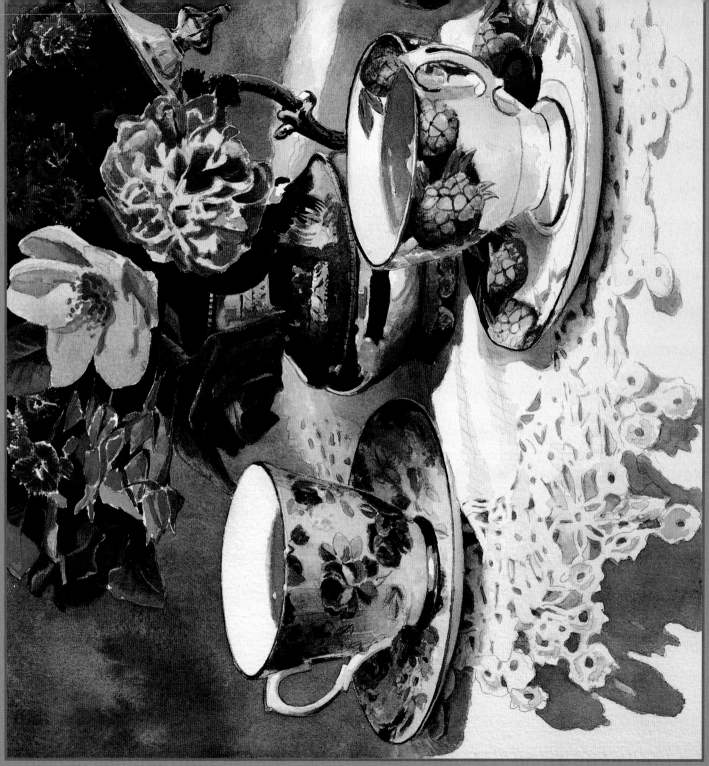

The image and title imply a heart-to-heart conversation over a cup of tea, but the viewer may see a different story. Suggestion is often more effective than telling everything.

Heart to Heart
Watercolor on 300-lb. (640gsm) cold-pressed paper
10" × 14" (25cm × 36cm)
Private collection

Painting the *Things You Love*

For years I avoided painting picky things such as lace. But I'm a logical person, and it finally occurred to me that if I could paint a leaf then I should be able to paint something more intricate. After all, the only difference between a leaf and lace is shape and detail. The painting process is the same. I discovered that if I consistently painted the same way, no matter what the subject matter, the painting worked. Thus I came up with my painting philosophy: If I follow the rules, it will work.

My rules are: work light to dark, loose to tight. As you paint the demonstrations in this chapter, notice how methodical it is to work this way. The lightest value is often just the white paper. The next lightest value is painted very loosely and the next value is painted a little tighter, and so on. The last thing you paint will be your darkest values and your tightest detail. If you make a conscious effort to paint (and think!) light to dark, loose to tight, it will become easier to figure out how to paint more complicated subject matter. When you're a little apprehensive about tackling a difficult painting, remind yourself, "If I follow the rules, it will work." And it does!

CHAPTER FOUR

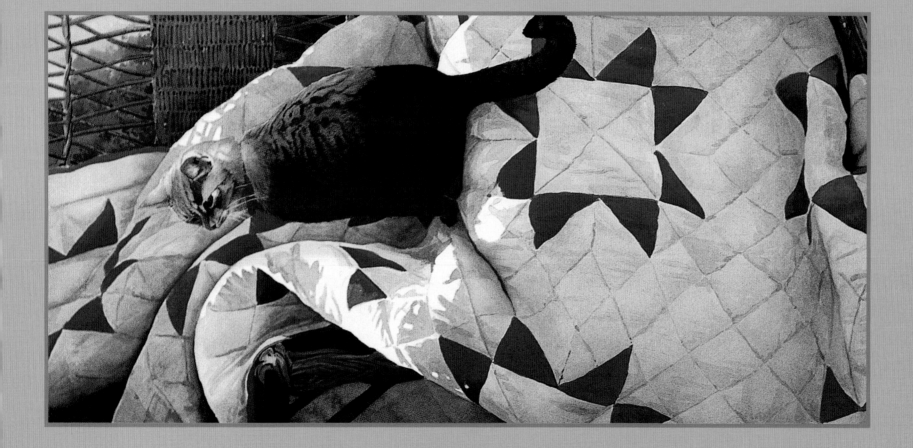

A draped quilt offers exciting possibilities. It can be combined with other subject matter—a cat, a child, a toy—and can be arranged to complement your composition. Using transparent colors and allowing the white of the paper to be the lightest part of the quilt will give the sparkle of sunlight to your painting.

Materials List

Surface
300-lb.(640gsm) cold-pressed watercolor paper

Paint
Alizarin Crimson ❖ Cobalt Blue
French Ultramarine Blue
Permanent Rose ❖ Raw Sienna

Brushes
no.8, no.4 rounds

Other
2H pencil ❖ Kneaded eraser

Photo Reference

If you want to do a painting of a cat or dog sitting on the quilt, it's easier to photograph them separately. Make sure the light source is the same for both photographs. When you photograph the quilt, put something heavy on it where you are going to place the cat or dog. A brick works well. This will make the quilt drape as if the pet was actually sitting on it.

Scanned Color Reference

You can zoom in on part of a reference photo with a color copier. Mark the section you want to enlarge and take it to your local copy center to have just that section enlarged.

Value Reference

Make a black-and-white photocopy or scan of your photo reference. This eliminates the colors of the quilt pattern, making the value of the shadows easier to see. Determine which areas you are going to save as white paper.

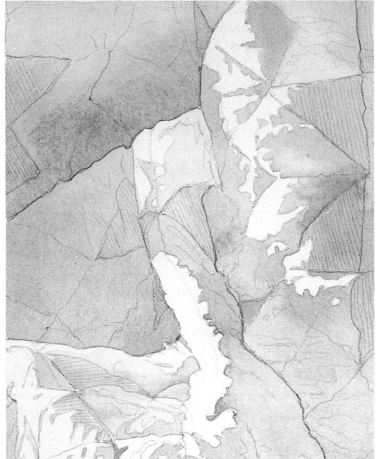

1 Complete the Drawing and Plan the Values

Do a light drawing using a 2H pencil. Make sure you draw the pattern of the sunlight on the quilt. When the drawing is finished, mark the triangles of the quilt pattern with some fine lines or crosshatching. This will help you make sense of your drawing as you paint the quilt. You can erase these fine lines after the painting is finished. Use a kneaded eraser to avoid damaging your paper.

Mark the sunlit areas of the quilt that will remain as white paper with a little **X** so that you don't accidentally paint them, or tape a piece of tracing paper over your drawing and trace the sunlit areas on the tracing paper. When in doubt about which areas to leave white, flip the tracing paper over your painting and you'll be able to identify these sunlit areas easily.

2 Apply the First Washes

Look at the color reference photo and notice how much color there is in a white quilt! In this step you will paint in the second lightest value and the underlying color of the shadow. Use a no. 8 brush to paint a wash of Cobalt Blue and Permanent Rose over the entire quilt, except for the white areas you are saving. Vary the ratio of blue to rose so that some areas look pinker, and some bluer. Notice the yellow-orange on the fold in the lower left corner? Perhaps the quilt is reflecting color from the floor. The upper right corner of the quilt also has some warm color. Use Raw Sienna and Permanent Rose to put a warmer wash over these areas. Ignore the triangles of the quilt pattern at this time. When you get to tighter areas, switch to a no. 4 brush.

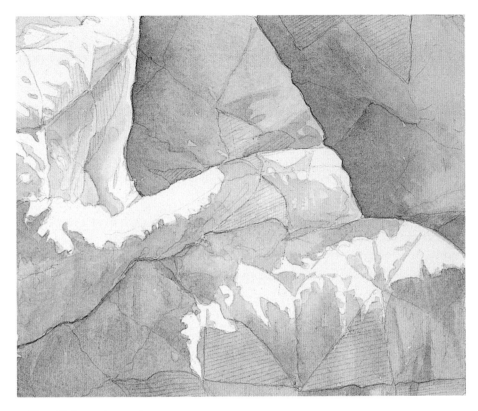

3 Add the Medium Values

On dry paper, use a no. 8 brush to define the medium values of the quilt using a wash of Cobalt Blue, Permanent Rose and Raw Sienna, slightly darker than the wash you used in step 2. Vary the ratio of colors in the mixture so it is pinker in some places, bluer in others. Don't worry about hard edges. If you look at the reference photo, you will see hard edges there too. You won't be painting over all of the wash done in step 2, just part of it. The folds of the quilt start to develop as the values become stronger.

Use the black-and-white reference and look closely at how the values are darker in the fold and lighter as the material flattens out. To paint a fold, where the values change from dark to light, paint the darker part of the fold, then lighten the value and soften the edge by dragging the color out with a damp brush. Don't worry about any detail yet. Just work on defining the value changes of the quilt folds. In tight areas, switch to a no. 4 brush.

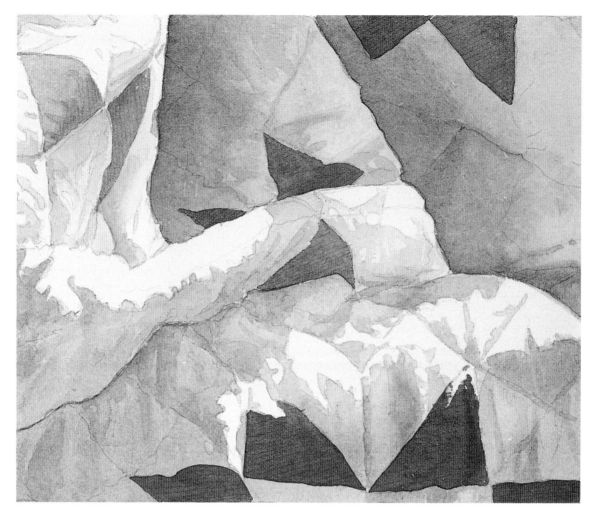

4 Add Local Color

Before you add local color to the quilt pattern, double-check the values of the quilt. Turn your reference photo and your painting upside down and compare the values by squinting at them. It's easier to make corrections to the folds before you add color to the triangles.

Paint the triangle quilt pattern a pinky-red for fun, even though in the reference the quilt pattern is blue. Paint a medium-value wash of Permanent Rose and Alizarin Crimson over all of the triangles, except for the one in the upper-left corner. The upper-left triangle is in sunshine, so dilute your Permanent Rose-Alizarin Crimson wash a little before painting it. You already underpainted these triangles in the previous steps so they already have some value changes.

5 Add the Dark Details

Before painting the red triangles in the previous step, I was comfortable with the value and color of the quilt. But as soon as I painted the triangles red, the upper-right corner of the quilt suddenly looked a little colorless. Add a wash of Raw Sienna and Permanent Rose to give that area a little more oomph.

In the reference photo, the quilting stitches look like dark lines. If it works in the reference photo, it will work in your painting. Using a darker mixture of Cobalt Blue and Permanent Rose, paint these lines and the little puckers that make a quilt look quilty, but don't try to paint detail you can't see in your reference photo. Now paint the darkest darks in the quilt folds using Permanent Rose, Cobalt Blue and Raw Sienna. A little French Ultramarine Blue added to this mixture will make the mix even darker. Paint the darkest darks on the red triangles and you're done. See how these last dark values have given the quilt depth?

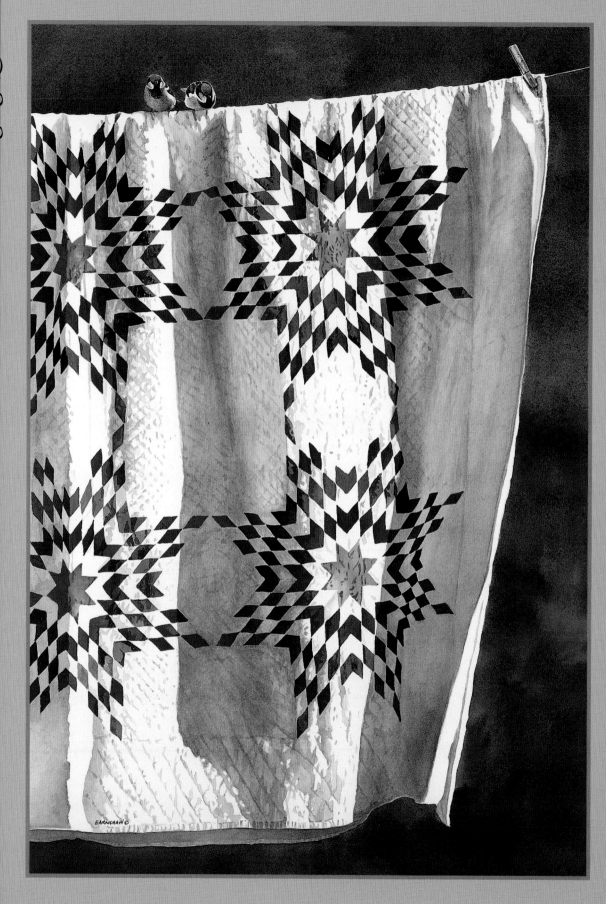

EARNSHAW

Show the sunlight on the folds of your quilt and it becomes more than just a painting. It will remind viewers of the sweet smell of sundried linens and the cozy feel of home. Use transparent colors and allow the white of the paper to be the lightest, sunlit part of the quilt. Simplify the process by painting the shadows before painting the colors of the quilt.

Materials List

Surface
300-lb. (640gsm) cold-pressed watercolor paper

Paint
Alizarin Crimson ❖ Aureolin
Cobalt Blue ❖ New Gamboge
Permanent Rose ❖ Quinacridone Sienna
Winsor Green

Brushes
no. 36, no. 8, no. 4 rounds

Other
2H pencil ❖ Kneaded eraser

Morning Star
Watercolor on 300-lb. (640gsm) cold-pressed paper
25" × 18" (64cm × 46cm)
Collection of Mr. and Mrs. Richard Thompson

Reference Photo
A quilt hanging completely flat on a clothesline won't have any shadows. By slightly gathering the quilt, folds are formed that create interesting shadows, emphasizing the sunlight on the fabric.

Value Reference
Make a black-and-white photocopy or scan of your photo reference. This eliminates the colors of the quilt pattern, making the value of the shadows easier to see. Determine which areas you are going to save as white paper.

1 Apply the First Wash

Complete a light drawing with a 2H pencil. Mark the whites with a small penciled **X** to help plan the values. You can erase the **X** later with your kneaded eraser. Remember to work light to dark, loose to tight. Pretend the quilt is a plain bedsheet and use a no. 36 brush to paint the lightest value of the shadows using a combination of Cobalt Blue and Permanent Rose on dry paper. The hard edges that form because the paper is dry are OK; shadows often have hard edges. Don't worry about showing any value changes in your shadows yet.

The shadows are more interesting if some parts are bluer and some parts pinker. At the edge of a shadow, try using another color combination to suggest reflected color. A mixture of Aureolin and Permanent Rose will add a warm edge to your shadow.

2 Give Depth to Your Shadows

Working on dry paper, mix the same combination of Cobalt Blue and Permanent Rose that you used in step 1, but use less water and more pigment to make a darker value. Use your no. 8 brush to paint all the darker areas of the shadows with this mixture, but leave some of the lighter areas that you painted in the first step. Don't worry about hard edges; but if a hard edge really bothers you, soften it with a damp brush while the edge is still wet.

Now you can start to add a little detail. Some of the white diamonds that are in shadow are darker on one side than the other. Use your no. 8 brush to paint these darker values with another glaze of the Cobalt Blue-Permanent Rose mix. Let the paper dry.

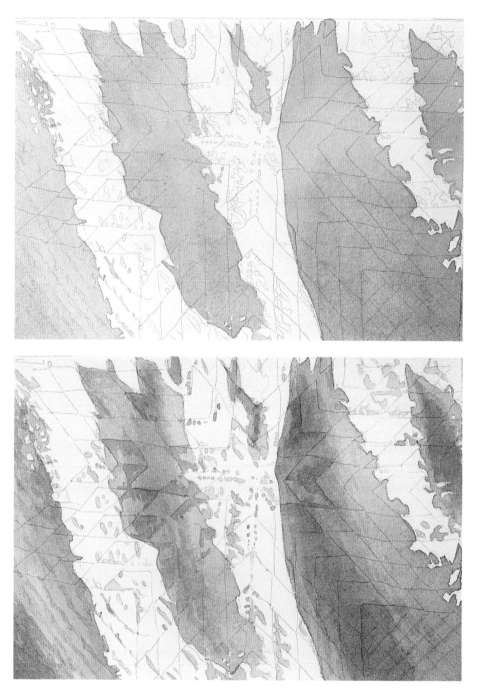

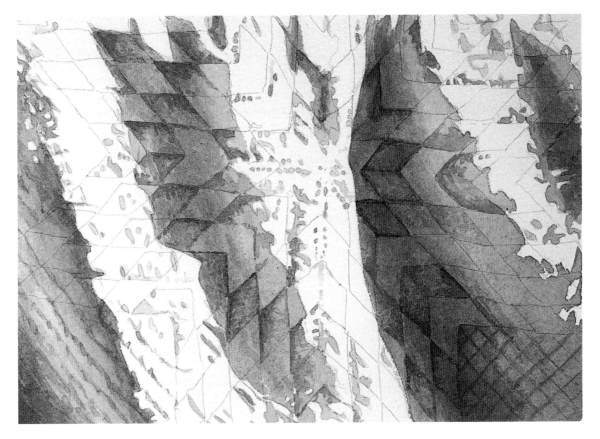

3 *Add the Darkest Details on the Shadows*

Use the same colors as before, mixing your paint with even less water than step 2. Now you can paint the darkest parts of the white diamonds, putting in puckers and stitches with your no. 4 brush. Prior to this you have been painting over areas that will become part of the quilt pattern, just because it's easier and faster to work this way. Now, however, you can concentrate your shadow detail just on the white diamonds.

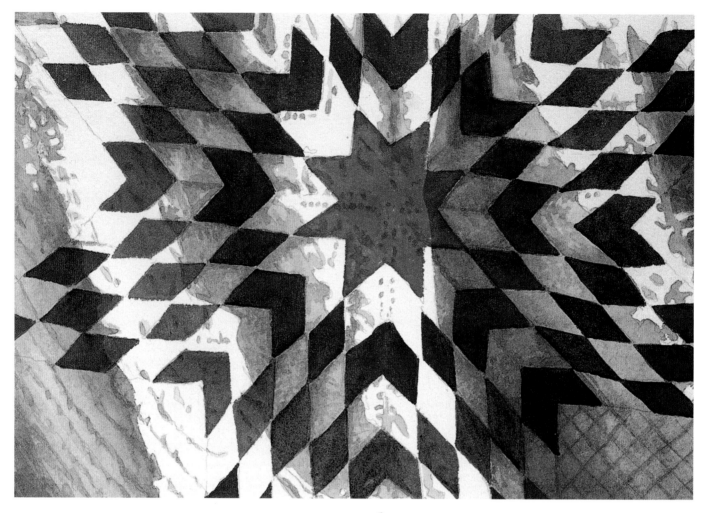

4 Paint Your Quilt Pattern

Paint the lightest value of the quilt colors. Paint the center star first, using your no. 8 brush with a mixture of New Gamboge and just a little Permanent Rose. Some of the blue shadows that were painted in previous steps will show through the yellow with a slightly green cast. Don't worry about it now.

Paint the red diamonds using Alizarin Crimson, adding a little Permanent Rose and even less Quinacridone Sienna. Now paint the green diamonds using Winsor Green and Cobalt Blue. Paint all of these diamonds in a flat color without any value changes.

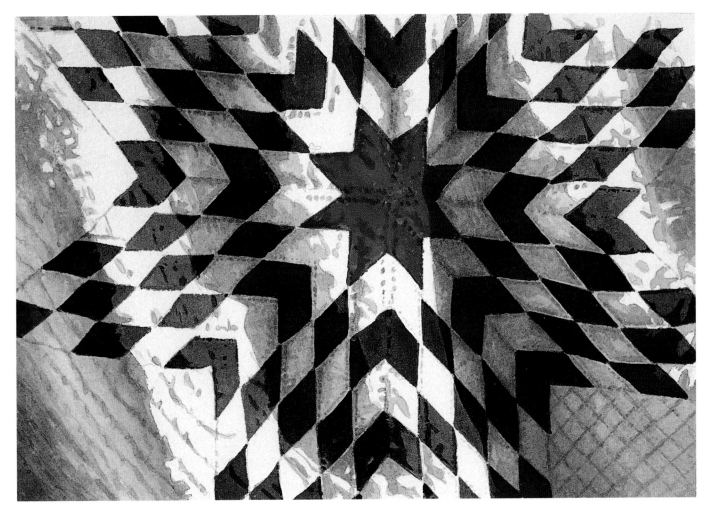

5 Give the Quilt Pattern Some Pop!

In this step, start with a no. 8 brush, but switch to a no. 4 brush when painting stitches or puckers.

Start again with the yellow center star, painting the shadow and stitch puckers with a darker mixture of New Gamboge, a little Alizarin Crimson and a little Cobalt Blue. Paint the darker values on the red diamonds with Alizarin Crimson, adding a little Winsor Green and a smidgen of Cobalt Blue. Finally, with a mixture of Winsor Green, a little Cobalt Blue and just a tad of Alizarin Crimson, paint the dark areas of the green diamonds. Bright colors can make it difficult to see value. Refer to the black-and-white photocopy of your reference or squint frequently to make sure your values on the quilt colors are correct.

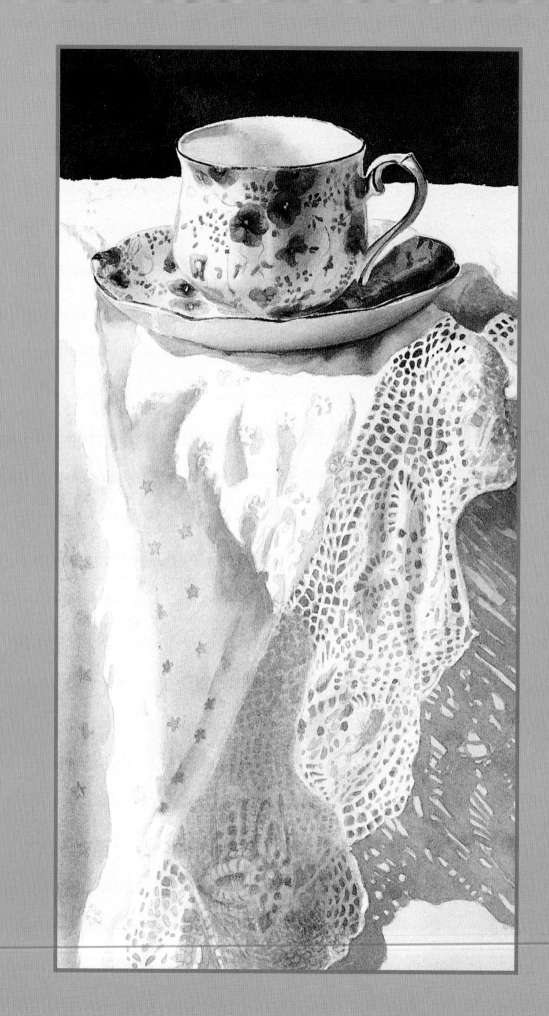

Painting china and lace requires an accurate and sometimes tedious drawing. Getting both an enlarged color copy and a black-and-white photocopy or scan will really help you understand the underlying values and intricate patterns of lace and china.

Materials List

Surface
300-lb. (640gsm) cold-pressed paper

Paint
Alizarin Crimson ❖ Aureolin
Cobalt Blue ❖ French Ultramarine Blue
Permanent Rose ❖ Raw Sienna
Winsor Green

Brushes
no. 8, no. 4 rounds ❖ Fritch scrubber

Other
2H pencil ❖ Kneaded eraser

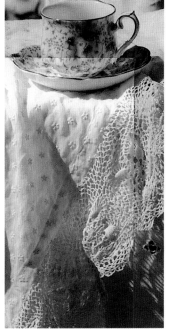

Photo Reference
I taped three different photos together here to create a nice composition.

Value Reference
It is difficult to see the values through the intricate pattern on the cup. This is why a black-and-white copy or scan of the reference photo is important.

1 Complete the Drawing and Plan the Values
Complete a light drawing with your 2H pencil. Draw the shadow shapes. Don't forget the white highlights on the cup and saucer rims. Recognize the parts of the teacup and lace that will remain white paper and mark these with a lightly penciled **X** to be erased later with your kneaded eraser.

The remaining steps of this demonstration treat the china and lace separately. Complete your drawing here as step 1. Proceed with steps 2 through 7 to complete the china (pages 60-62), then follow with steps 2 through 5 to complete the lace (pages 63-65).

Pansies and Lace
Watercolor on 300-lb. (640gsm) cold-pressed paper
16" × 10" (41cm × 25cm)
Private collection

CHINA

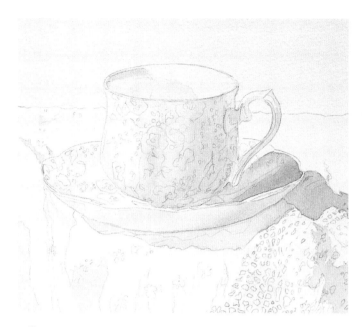

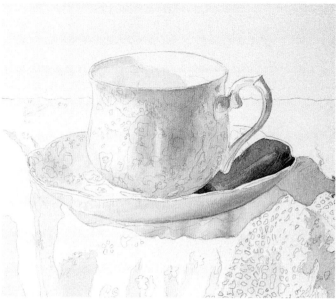

2 Apply the First Washes to the China

I didn't like where the back edge of the table intersected with the cup, so I lowered the table edge. This makes the negative shape behind the cup less rectangular and more interesting.

The light side of the cup is a very light value, so leave this part of the cup unpainted. Use your no. 8 brush to paint a light wash over the darker side of the teacup using a combination of Winsor Green, Aureolin and Cobalt Blue. Switch to your no. 4 brush to paint the tighter areas around the base of the cup and the handle.

Paint the left side of the saucer using the same pale Winsor Green, Aureolin and Cobalt Blue mixture. Then paint the right side of the saucer with the same combination, but use more Cobalt Blue. Make this wash slightly darker than the rest of the cup. You can see in the color reference photo how dark blue this side of the saucer appears.

Paint the underside of the saucer using the Winsor Green, Aureolin and Cobalt Blue combination, but change the ratio of blue to green to yellow because the left underside of the saucer is more yellow than the right side. Let these glazes dry.

3 Strengthen the Values in the China

Use a no. 8 brush to darken the values from the center to the right underside of the teacup and saucer using a Cobalt Blue-Permanent Rose mix. Rinse the brush, touch it to a paper towel to remove the excess water, and soften the left edge of the area you just painted. Drag the color out toward the left side of the saucer. Glaze the center of the teacup with pale Cobalt Blue, softening the left side of your glaze so that a hard edge doesn't form. Remember to keep the left side of the cup the white of the paper. Now quickly glaze the right side of the cup with some pale Aureolin, right up to the Cobalt Blue. If you have worked quickly, both areas will be equally wet and will blend nicely; if the Cobalt Blue is drier than the Aureolin, however, little blossoms (blooms) will appear where these two colors meet. (You can prevent blooms from appearing. Keep a paper towel handy and before you touch your brush to the paper, touch the tip of the brush to the paper towel to take off the extra water.)

Glaze inside the left side of the saucer with a mixture of Cobalt Blue and Aureolin. Glaze the right side of the saucer with a stronger wash of Cobalt Blue and a little Permanent Rose. Now paint the shadow under the saucer using this same combination. The inside of the cup is pale Aureolin with a little Cobalt Blue at the cup edge. Let it dry.

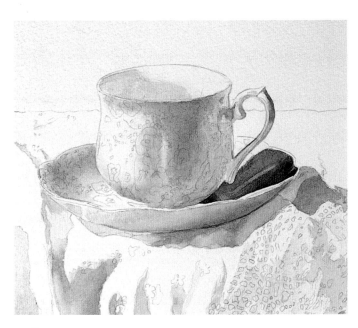

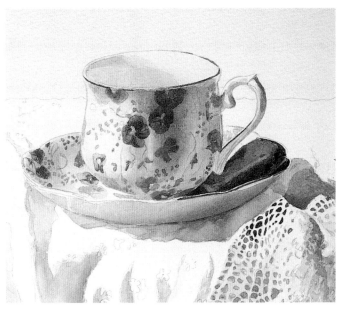

4 Finalize the Values in the China

Look at your black-and-white reference photo and painting upside down and really analyze the values. Squint! Does the dark side of the cup look as dark as your reference? If not, correct it now. It will be much harder to make value corrections after you paint the chintz pattern. Using the same color combinations you used in the previous step, but in a darker value, make the center front of the cup a little darker. Notice the lighter vertical band center front. You can lift this color out with a damp brush and paper towel. If you use a scrubber brush, be gentle. Don't damage the paper.

5 Paint the China Pattern

Look at your color reference photo and notice the different values in the blue pansies on the cup. On the left side they are fairly light in value, but in the center they are much darker. It will really help when you paint these flowers to methodically work from light to dark, loose to tight. Paint the broad pansy petal first using Cobalt Blue, allow the petals to dry, and then paint the darker blue lines that radiate to the center of the flower using French Ultramarine Blue. For the darker pansies, mix a little French Ultramarine Blue with the Cobalt Blue. Leave the light spot in the center of the pansy unpainted.

The leaves are primarily Aureolin with a tiny bit of Winsor Green added. Add a little Cobalt Blue to the mixture for the shadowed leaves. Notice that on the right side of the saucer you can barely make out the pansies. Paint what you see in your reference photo. If you can't make out the detail in your reference, then you don't need to put it in your painting.

Paint the dark lines around the rim of the saucer and cup using Alizarin Crimson, Winsor Green and French Ultramarine Blue.

What Color Is It?

When you're having trouble getting the right color or value, use this little trick. Cut a small hole in the middle of a white piece of paper. Put the paper over your reference photo so that you can see the problem color or value through this hole. Now quickly move the paper and put the hole over the corresponding spot in your painting. You'll be able to tell immediately if that spot in your painting is lighter, darker, or a different color than your reference.

♥

6 Plan the Background

Before painting the dark background, I scanned the painting on my computer. Using Photoshop, I added a dark blue background. You can also get a color copy of your painting and color the background in with a marking pen. Or cut a piece of colored paper the same shape as the background and lay it over the painting.

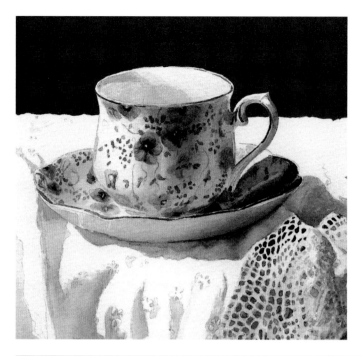

7 Finish the Pansies and Add the Background

Paint the dark red at the flower's center using Alizarin Crimson mixed with a little French Ultramarine Blue. Let it dry, then glaze over the light spot in the pansy's center with a little Cobalt Blue and Aureolin.

To paint the background, use mainly French Ultramarine Blue, adding just a tad of Alizarin Crimson and Winsor Green. Paint the background on dry paper. Start at the edge of the tablecloth to the left of the cup with your no. 8 brush, but have your no. 4 brush ready to paint around the edges of the saucer and cup. Move quickly, painting from the cup edge to the edge of the painting, all around the cup to the table edge on the right side. Don't give your brushstrokes a chance to start drying. Look at the teacup in a mirror. Does it look three-dimensional? Are the colors strong? This is the time to balance your values and add the final darks.

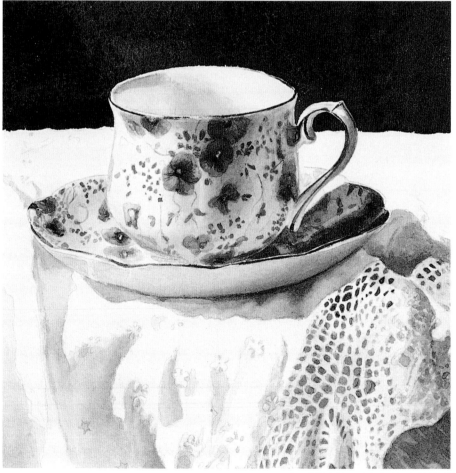

LACE

2 *Apply the First Washes to the Lace*
Ignore all the little lace holes for now and pretend it is just a solid piece of fabric. Use your no. 8 brush to paint the shadows with a light wash of Permanent Rose, Raw Sienna and Cobalt Blue. Vary the ratio of these three colors as you paint, allowing one side of a shadow to be bluer or pinker than the other. The far right side is a linen tablecloth that is under the lace. For now, just give it a wash of Raw Sienna and Permanent Rose.

3 *Strengthen the Values in the Lace*
With your no. 8 brush, hit parts of the shadows with Raw Sienna, softening the edges with a damp brush. Where the shadows are darker, add some Cobalt Blue, softening the edges. Using your no. 4 brush, paint the shadow pattern on the linen cloth with a combination of Cobalt Blue and Permanent Rose. Add Raw Sienna as you work your way toward the bottom of the shadow.

4 Define the Lace

Paint all the lace holes with a light value of Raw Sienna, Permanent Rose and Cobalt Blue. Remember, the goal is to paint a suggestion of lace, not a photographic reproduction that will surely drive you nuts. Let it dry.

Notice how the lace holes are different values? Some are very dark, some are very light, but most are a middle value. Now go back and darken some of them using your reference as a guide. Some holes may be only partly dark. Use the same combination of Cobalt Blue, Permanent Rose and Raw Sienna.

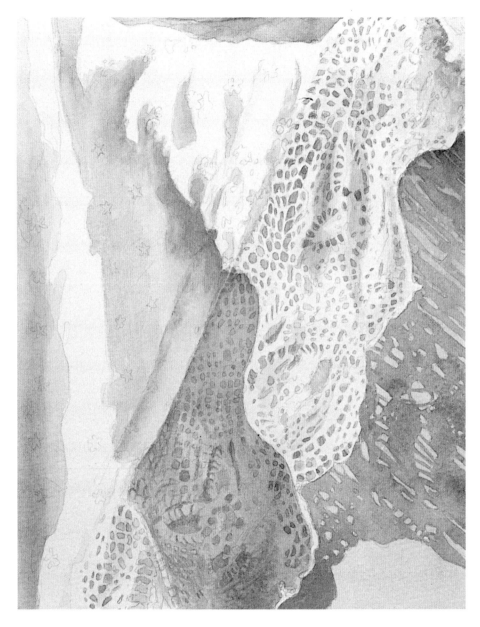

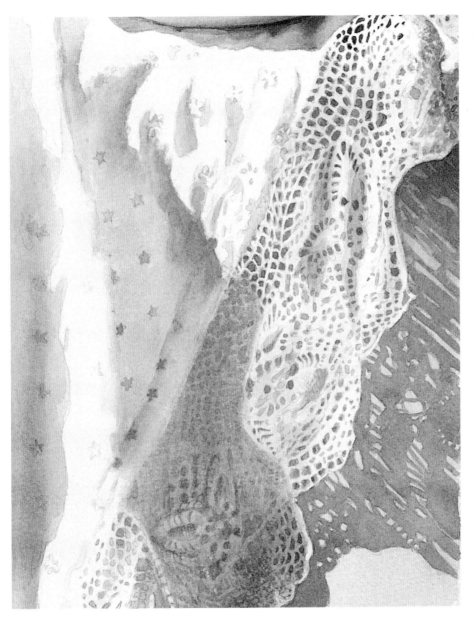

5 Finish Developing the Values

Paint the little flowers on the tablecloth with Cobalt Blue and Permanent Rose.

Step back and take a critical look at your lace. Look at it in the mirror. If the lace is too wishy-washy, perhaps you need to add color to your shadows. Are your values dark enough? Do you have the edges you want? Look at your color reference and your painting side by side and upside down before you pronounce it finished!

The shadow on my tablecloth doesn't seem deep enough so I give it another glaze of Permanent Rose and Cobalt Blue. The shadow in the center has too hard an edge so I scrub it with a Fritch scrubber to soften it.

Remember, there is a fine line between done and overworked, especially when doing detail work like lace. Better to leave it slightly underdone than to "noodle" it to death.

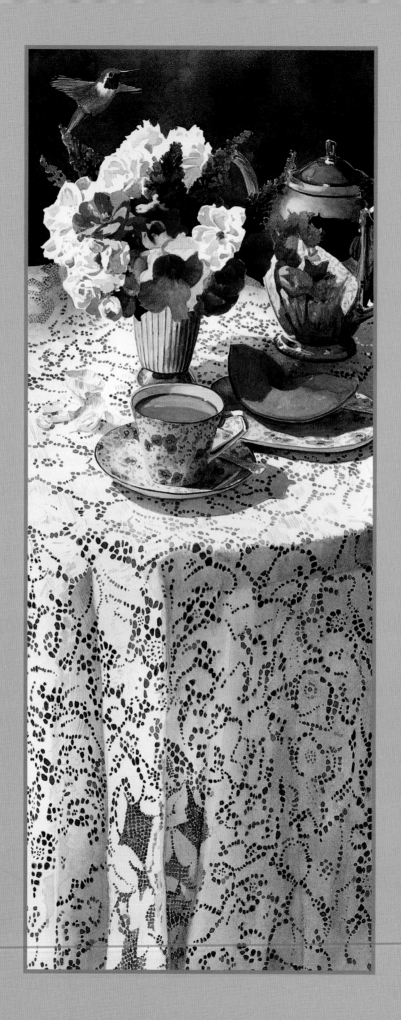

Although I like the silver pitcher in one of my reference photos, I prefer the flowers in another. No problem! In chapter 3 we discussed how to use multiple photographs for one painting and this is what we will do here.

Materials List

Surface
300-lb. (640gsm) cold-pressed paper

Paint
Alizarin Crimson ❖ Aureolin
Cobalt Blue ❖ French Ultramarine Blue
New Gamboge ❖ Permanent Rose
Quinacridone Gold ❖ Raw Sienna
Rose Madder Genuine ❖ Winsor Green

Brushes
no. 8, no. 4 rounds

Other
2H pencil ❖ Kneaded eraser
Dr. Martin's Bleed-Proof White

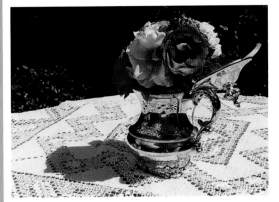

Reference Photo for Silver
Silver is so reflective that it tends to get lost against either a dark or light background when you photograph it. You can see in the reference photos that parts of the silver pitcher have disappeared against the lace tablecloth.

Value Reference for Silver

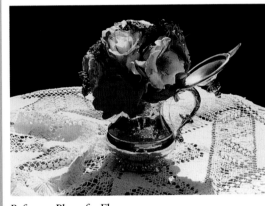

Reference Photo for Flowers
This shot gives a better portrayal of the flowers.

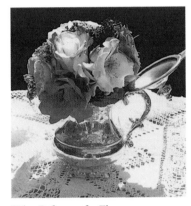

Value Reference for Flowers

Breakfast for Two
Watercolor on 300-lb. (640gsm) cold-pressed paper
23" × 12" (58cm × 30cm)
Collection of Lt. Col. Peter and Mrs. Anne Pitterle, USMC
(Ret.)

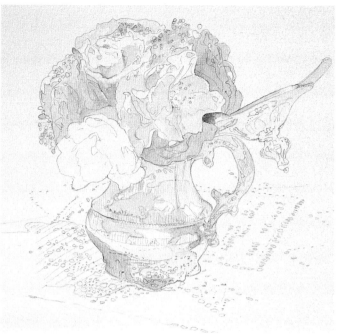

1 Complete Your Drawing

Complete your drawing with your 2H pencil using the pitcher from one photograph and the flowers from the second photo. I know the shape of the silver pitcher so I am able to pencil in edges that got lost in the background. Draw all the detail—the little blobs of dark, the shapes that will stay the white of the paper and the detail on the handle. Use your kneaded eraser to avoid damaging the paper.

Don't try to draw each petal of the flowers. If you can't distinguish where one petal ends and the other begins, then paint it that way. Remember to save the white of the paper for the lightest value on the center roses. This is how you will give the effect of sunlight bouncing off the petals.

Crosshatch the dark areas to serve as landmarks when you paint.

2 Lay the First Washes

Leave a few spots on the lid rim and the lower left side of the pitcher as the white of the paper. Glaze the light parts on the dark band across the center of the pitcher with a little Cobalt Blue, using your no. 8 brush. Glaze the other lighter values of the pitcher, including the handle and lid, with a pale mix of Raw Sienna and Permanent Rose. Look carefully at the lid; a few spots need a wash of Cobalt Blue. Switch to a no. 4 brush for the more detailed areas.

Glaze the pink roses on the left with a thin wash of Rose Madder Genuine. Wash over the mauve rose on the right with a light mix of Rose Madder Genuine and Cobalt Blue. Wash the pale multicolored rose with the gold center with an underpainting of Aureolin and Rose Madder Genuine, saving the white of the paper for the top petals of this flower. (Hopping around the arrangement like this allows each flower time to dry before you paint the flower next to it.)

The pretty yellow rose with pink edges has a lot of white paper in the center. Underpaint the yellow part of the rose with a thin wash of Aureolin. Paint the pink edges with Permanent Rose.

Don't paint the red rose yet. Other than one petal edged in light, the lightest value on this rose is dark so you will paint it in a later step.

There's a white rose at the top of the arrangement, but because the background of this painting will be the white paper, we'll change the color of this rose to pink.

Paint the light values on the buddleia (purple butterfly bush) with a Permanent Rose-Cobalt Blue mix. Paint the yarrow (pink, frothy flower) with Permanent Rose. Paint the little bits of green with a Quinacridone Gold-Winsor Green mix.

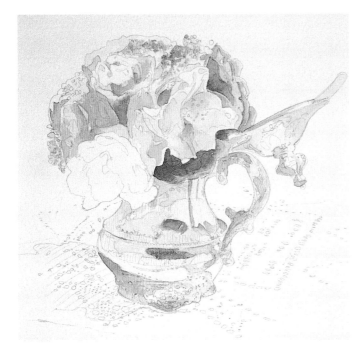

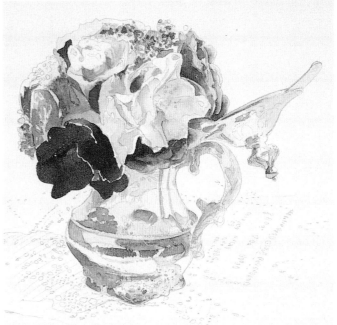

3 Paint the Middle Values

Use your no. 8 brush to wash the middle values of the handle and the foot of the pitcher with Raw Sienna and a little Cobalt Blue. The bump on the inside part of handle is warmer, so add some Permanent Rose to this spot. The dark reflection across the center of the pitcher is reflecting blue sky and clouds. Wash this blue with a medium value of pure Cobalt Blue. Paint the streak on the right side of the pitcher with a Permanent Rose-Raw Sienna mix, but add blue as it moves upward. Apply a pale glaze of Raw Sienna to the lid, adding a tiny bit of Winsor Green as you move closer to the flowers.

Putting in the middle values of the flowers will start to give the flowers depth. With a medium-value wash of Cobalt Blue, Rose Madder Genuine and your no. 8 brush, glaze the petals of the mauve rose on the right. Apply the color just at the bottom and soften it with a damp brush, dragging the color out to a lighter value. Now do the same with the pink rose on the left with Rose Madder Genuine, and the yellow rose with New Gamboge, adding Permanent Rose at the base. The pale rose with the gold center has many colors. The center is blue, so use Cobalt Blue. The edges of the petals are pinker, so use Permanent Rose here. Leave the red rose unpainted for now.

4 Develop the Middle Values

The bottom half of the pitcher's dark reflection has blue in it, so paint that entire section French Ultramarine Blue and Permanent Rose using your no. 8 brush. Remember that we are using the pitcher from one photograph and the flowers from another. If you look at the reference photo you are using for the flowers, you'll notice that the red rose is reflecting in the silver. Using Permanent Rose and New Gamboge, use your no. 8 brush to paint a reflection as you see in the flower reference photo. Then switch to your no. 4 brush and paint some of the darker values in the base of the pitcher using Raw Sienna and Cobalt Blue. Systematically paint all the darker medium values, without putting in detail yet.

Use your no. 8 brush to wash the red rose in a dark-medium wash of Alizarin Crimson, Permanent Rose and New Gamboge. Leave a white edge around a few of the petals. This initial wash covers up most of the drawing. The white edges will serve as landmarks as you paint the rose.

Develop the medium values in the other roses, using the same color mixtures as in the previous steps, but with less water to make the values stronger.

As the values get darker and more detailed, you'll use your no. 8 brush less and your no. 4 brush more. Remember you are working loose to tight, light to dark.

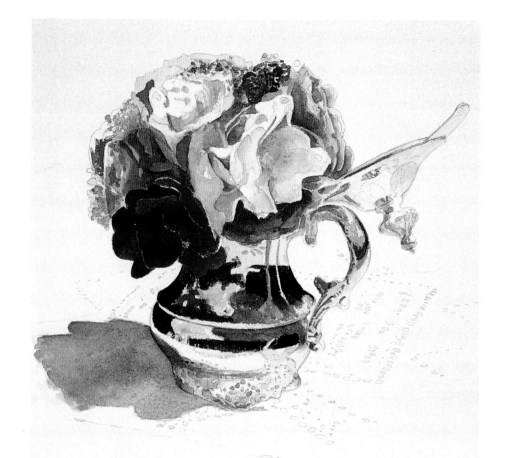

5 Start the Detail Work

Use your no. 8 brush to paint the dark band around the middle of the pitcher. This area has two values: the dark, almost-black value and another a little lighter. Paint all of your darks this second-to-darkest value using your no. 8 brush and a mixture of Alizarin Crimson, Winsor Green and French Ultramarine Blue. Now get picky and paint some of the looser detail at the base of the pitcher with your no. 4 brush and a Cobalt Blue-Raw Sienna mix. Define the detail in the lid and handle with this same combination. Use Cobalt Blue on the handle of the lid.

The shadow will help anchor the pitcher to the table, but doesn't need much detail. Use your no. 8 brush to paint the shadow with a combination of Cobalt Blue, Permanent Rose and Raw Sienna. Start at the back of the shadow and as you move toward the front of the shadow, add more Raw Sienna to the mixture.

Use your no. 8 brush to apply a dark mix of Alizarin Crimson, New Gamboge and French Ultramarine Blue for the darker values on the red rose. Don't worry about detailing this rose too much. Switch to your no. 4 brush and hop from flower to flower, darkening values, using the same color combinations as in the previous step, but with less water in the mixture.

The overlapping petals and areas between petals can be confusing. Use your no. 8 brush and a medium wash of Permanent Rose to glaze over the areas between the flowers. This will unify these confusing spots, giving them some cohesiveness and knocking back the value in these areas, making them less prominent.

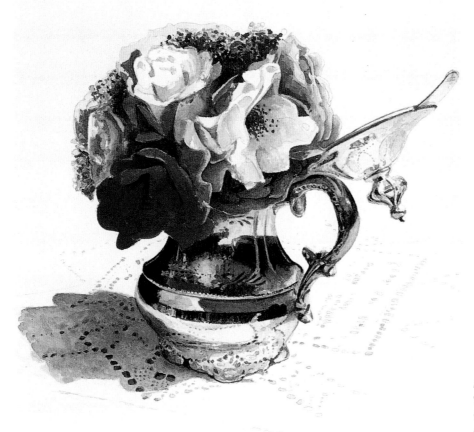

May Flowers
Watercolor on 300-lb. (640gsm) cold-pressed paper
9" × 10" (23cm × 25cm)
Collection of Wick Ahrens

6 Make It Pop

Use your no. 8 brush and a medium-value mix of Cobalt Blue and Permanent Rose to darken the shadow closest to the pitcher on the tablecloth; then soften the edge.

With a medium-value wash of Cobalt Blue, glaze over the dark middle band on the pitcher, except for the palest value left of center. This pulls together all the areas you previously painted. Once dry, if the palest value left of center is too light, knock it back with a pale wash of Cobalt Blue and Raw Sienna.

Darken the lower left side of the pitcher, using a no. 4 brush and a mixture of Alizarin Crimson and Winsor Green to make it stand out a little against the shadow.

Use your no. 4 brush and a mixture of Winsor Green and Alizarin Crimson to noodle the dark detail on the handle. If you're hesitant to darken an area, pencil it in first with your 2H pencil. If you don't like it, the darker value can be erased. Don't forget the darks and reflected lace holes on the lid. Once you finish the darks on the pitcher and your paper is dry, glaze over the base and the handle of the pitcher with Raw Sienna, sometimes adding a tiny bit of Permanent Rose to the mix. This softens the hard edges of your darks a little and adds color to the silver. If your pitcher appears a little flat, use a damp brush on dry paper to lift a little line of paint on the right and left sides of the pitcher, just about

$\frac{1}{16}$ inch (2mm) in from the edge. Now on the light parts of the pitcher reverse the process, putting a slightly darker-value line just a little in from the edge. This will make the pitcher look round. Next paint the lace holes on the tablecloth using your no. 4 brush and a Cobalt Blue-Permanent Rose mix. Add some French Ultramarine Blue for the darker spots. Don't try to detail the lace tablecloth. It will detract from the silver and flowers.

If there are highlights on the dark parts of the silver that you left out, you can either lift the paint, using a damp brush and paper towel, or use a bit of Dr. Martin's Bleed-Proof White to reintroduce the highlights.

Putting the darks in the flowers will really make the arrangement pop! Paint the green of the yarrow with a medium combination of Quinacridone Gold and Winsor Green. Then while it is still wet, hit the base of the yarrow with a dark Quinacridone Gold-Winsor Green-Alizarin Crimson mix. This will soften into the still-wet lighter wash you just applied.

Paint the gold center of the pale rose using New Gamboge and Permanent Rose. For the dark center, add a little French Ultramarine Blue to the mixture. Saving the white paper for the lightest value and using transparent watercolors will give your flowers color and vibrancy.

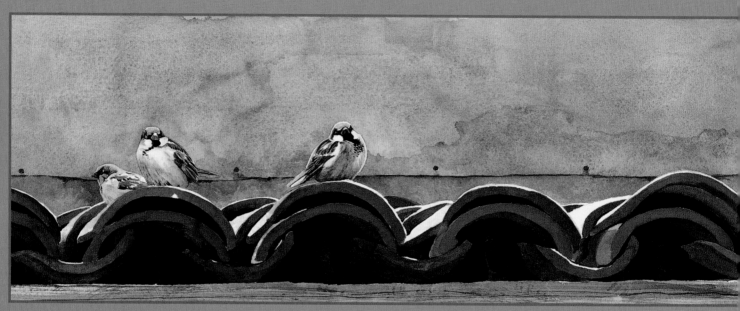

A repetitive pattern makes an interesting composition
when broken by a focal point.

Adding a
Tender Touch

Los Gorriones
Watercolor on 300-lb. (640gsm) cold-pressed paper
6" × 26" (15cm × 66cm)
Private collection

In this chapter, I will show you how I add a living focal point to a painting. A painting of a statue, a quilt or a flag is inanimate. Add a soft, living bird and the painting has life and a focal point. It also widens your market. A quilt painting without a bird appeals to a small market of quilters and quilt lovers. Add a bird and the painting appeals to nature lovers, too.

CHAPTER FIVE

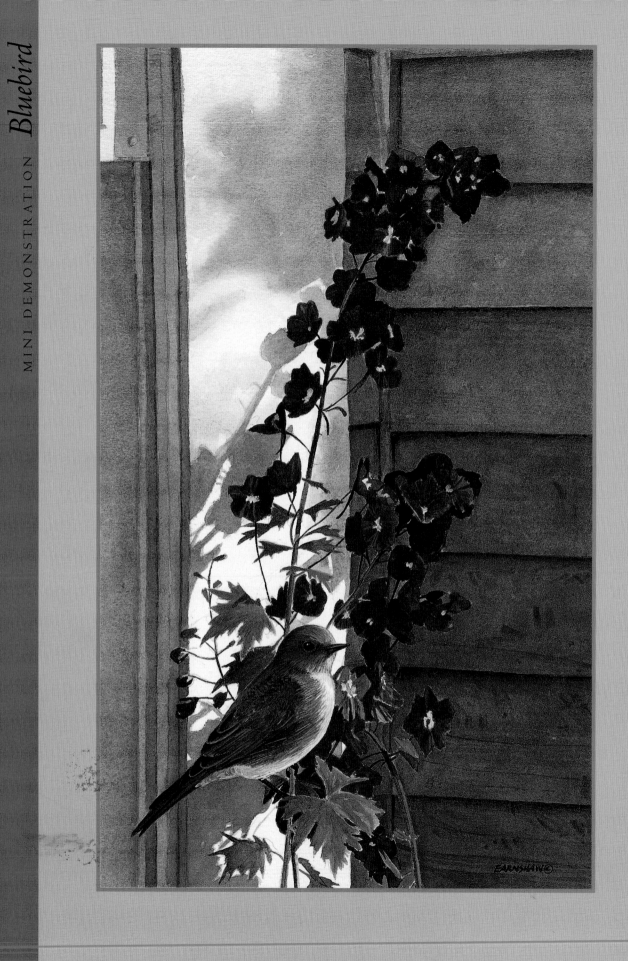

A bird painting doesn't have to be detailed, but it does have to be accurate. Make sure the bird is found in the habitat you are painting and check that the size of the bird is in scale to its surroundings. I carry a little ruler in my camera bag. When photographing habitat, whether natural or man-made, I include the ruler in the photograph. A bird guide, such as *National Geographic's Field Guide to the Birds of North America* (National Geographic Society, Washington DC, 1983), will give the size of the bird, where it is found, and a good description. I also refer to *The Audubon Society's Encyclopedia of North American Birds* by John K. Terres (Alfred A. Knopf, Inc., New York, 1980). It has more comprehensive information than a field guide. For researching birds in Europe try *Collins Photo Guide: Birds of Britain and Europe* by Stuart Keith and John Gooders (Collins, London, 1980).

Materials List

Surface
300-lb. (640gsm) cold-pressed paper

Paint
Alizarin Crimson ❖ Cobalt Blue
French Ultramarine Blue
New Gamboge
Quinacridone Sienna ❖ Raw Sienna
Winsor Blue ❖ Winsor Green

Brushes
no. 8, no. 4 rounds

Other
2H pencil ❖ Kneaded eraser
Dr. Martin's Bleed-Proof White

Delphinium Blue
Watercolor on 300-lb. (640gsm) cold-pressed paper
16" × 10" (41cm × 25cm)
Collection of Liz and Ty Schuiling

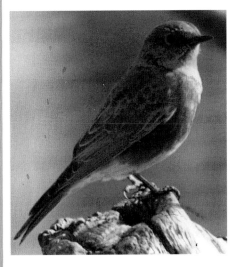

Reference Photo
If your reference is a little dark, as mine is, hold a flashlight behind the photo or tape it to your desk lamp so the light shines through the photograph. You'll be surprised how much more you can see.

1 **Complete the Drawing**
Use a 2H pencil, drawing lightly so as not to leave an indentation in the paper. Put in a lot of detail, even if you don't paint it in later. The detail will allow you to see the structure of the bird, such as the wing, as you paint. Use a kneaded or art gum eraser to avoid damaging the paper when you erase.

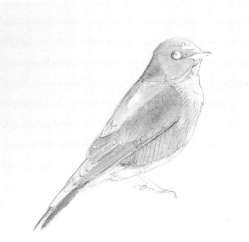

2 Apply the First Washes

First, recognize which parts of the bird will remain the white of the paper. Then using your no. 8 brush, knock in the lightest values on dry paper. The head is a thin wash of Winsor Blue and French Ultramarine Blue. The chest is painted using New Gamboge and Quinacridone Sienna. Switch to your no. 4 brush when you are painting tight areas, such as around the eye.

Paint the shoulders of the bluebird using the same New Gamboge-Quinacridone Sienna combination, but use less New Gamboge this time.

Notice how the edges of the primary and secondary feathers on the wings are a lighter value. Paint these feathers using your no. 4 brush and a mixture of Raw Sienna and a little Cobalt Blue. Paint the bird's rump with the same mixture. Let it dry before painting the top part of the wings with a wash of Winsor Blue and French Ultramarine Blue. Soften the edge of the color at the top of the wing so that it bleeds nicely into the Quinacridone Sienna-New Gamboge mixture that you painted on the shoulder. Keep your Winsor Blue-French Ultramarine mixture clean and unpolluted by other colors by wiping your palette off first. This will help keep these colors bright.

Paint the entire wing using your no. 4 brush and the same Winsor Blue-French Ultramarine wash. Don't paint the edge of the wing feathers that you have already underpainted in Cobalt Blue and Raw Sienna. Carry this blue wash down the length of the tail.

3 Add the Middle Values

Using your no. 4 brush with a nice tip, paint the eye with a very dark mixture of Winsor Green and Alizarin Crimson. Leave a little white spot of paper as a highlight.

Using your no. 4 brush and a medium-value mixture of French Ultramarine Blue, Winsor Blue and Cobalt Blue, paint the middle values on the head and wings. Where there is no value change within the color, as on the tail or eye, you can paint the final value in one step without glazing or layering.

With your no. 4 brush, paint the lighter-medium values on the chest using New Gamboge, Quinacridone Sienna and a little Alizarin Crimson. Paint the beak with a light value of Raw Sienna and Cobalt Blue.

Paint the back of the bird with Winsor Blue and Cobalt Blue, paying close attention to the way the feathers lie. Don't try to paint every little feather. Unless you are looking at a bird very closely, you don't see individual feathers; they are simply indicated by a slightly bumpy texture on the bird's back. If the feathers start to look too defined, soften them with a damp brush once the painting is dry. As you paint the longest feathers on the bluebird's wing, remember to leave the feather's edge a lighter value.

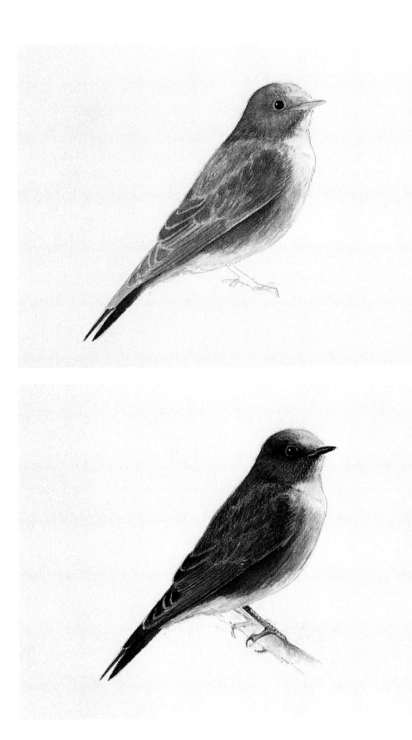

4 Add Darker Values

Using your no. 4 brush, make a medium-dark mixture of French Ultramarine Blue with a tad of Winsor Blue. Remembering the light-to-dark, loose-to-tight rule, start to define the bird's head and wing with this darker blue mixture. Add a little Alizarin Crimson and Winsor Green to some French Ultramarine Blue and paint a darker value on the bird's longest wing feathers. With Alizarin Crimson, Quinacridone Sienna and a bit of French Ultramarine Blue, paint the darker areas of the bluebird's breast. Use Alizarin Crimson, Winsor Green and French Ultramarine Blue to darken the beak a little.

5 Add the Final Touches

Use your no. 4 brush and a fairly dark mixture of French Ultramarine Blue and a little Winsor Blue to add the final darks to the head and wing. Add some Alizarin Crimson and Winsor Green to the blue mixture for the darkest values on the long wing feathers. Mix a dark value of Alizarin Crimson and Quinacridone Sienna to darken the area right under the bird's wing. Then do the final darks on the beak using Alizarin Crimson, Winsor Green and French Ultramarine Blue.

Paint the feet using Raw Sienna and a little Cobalt Blue. When this wash is dry, use Alizarin Crimson, Winsor Green and French Ultramarine Blue to add some darks to the feet. You can suggest the feet without bothering with detail.

Mix a little Dr. Martin's Bleed-Proof White with Quinacridone Sienna and using your no. 4 round brush, paint a few fine feathers where the breast feathers overlap the top of the wing. Be careful using white. If you use just a little for highlights, it's an effective tool. If you use too much, your painting will look chalky.

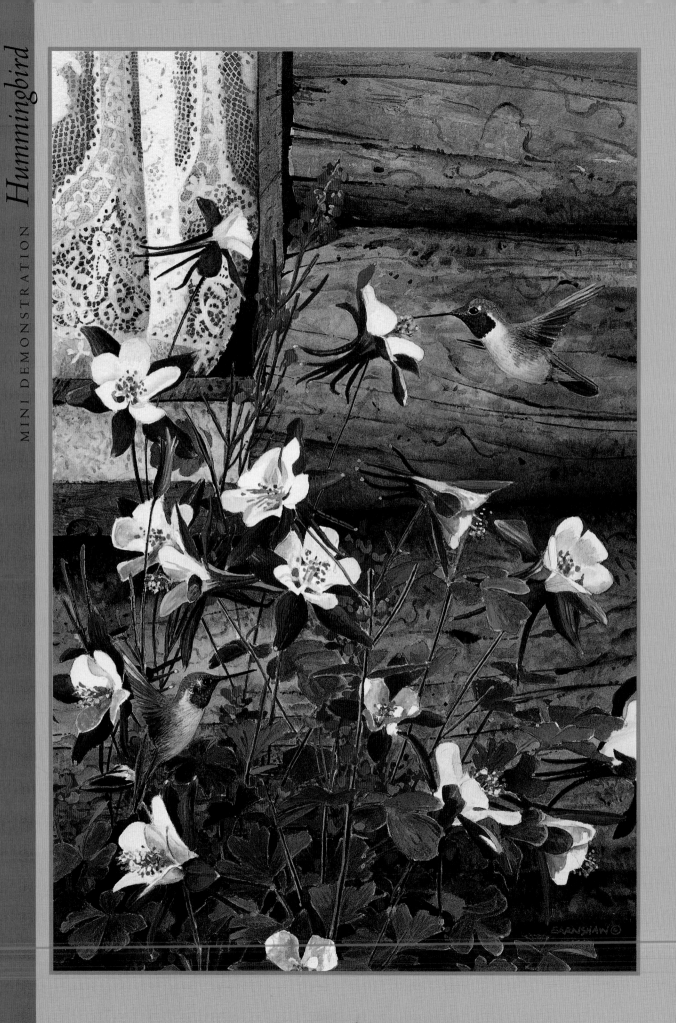

My painting of geraniums (at left) wouldn't feel the same without a bird. Hummingbirds are easy to paint. When you paint a bird, make sure the bird is in scale to its surroundings. We tend to paint hummingbirds smaller than they really are. The garden variety of hummingbirds common to North America average 3½" to 4" (9cm to 10cm) in length.

This demonstration can be applied to other birds, too. There are many small garden birds that could be substituted.

Materials List

Surface
300-lb. (640gsm) cold-pressed paper

Paint
Alizarin Crimson ❖ Aureolin
Cobalt Blue ❖ French Ultramarine Blue
New Gamboge ❖ Permanent Rose
Quinacridone Gold ❖ Raw Sienna
Winsor Green

Brushes
no. 8, no. 4 rounds

Other
2H pencil ❖ Kneaded eraser

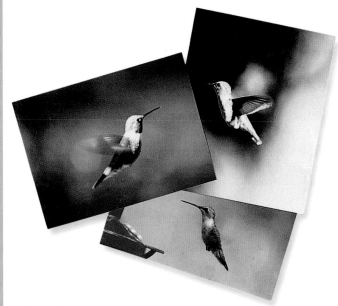

Reference Photos
If you don't have the right reference photo, use several photos to do your drawing. If you are having trouble with a wing, draw it on tracing paper, then lay it over the drawing of the bird to see how it looks. Flip the drawing if you want the bird to face the opposite direction.

As a reminder, don't violate copyright laws. The photograph(s) you use for your paintings must either be your own, or ones that you are legally allowed to use. You may use a field guide or published photographs for color reference or to understand detail that you can't see in your own photos.

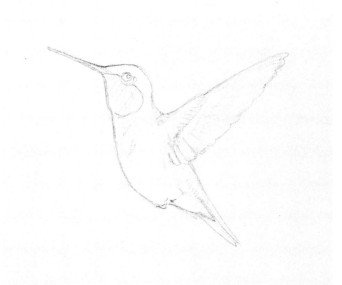

Rocky Mountain Summer
Watercolor on 300-lb. (640gsm) cold-pressed paper
15" × 10" (38cm × 25cm)
Collection of Grazina and Michael McClure

1 Complete the Drawing
This drawing was done from several different photographs, using a 2H pencil. Draw lightly so you don't make an indentation in the paper. If you must erase, use a kneaded or art gum eraser. Reverse your reference photo and try drawing upside down. It works!

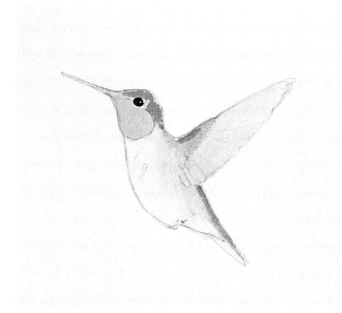

2 Apply the First Washes

Although the eye is dark, paint it now using your no. 4 brush and a dark combination of Winsor Green, Alizarin Crimson and French Ultramarine Blue. The eye gives the bird life and makes it easier to paint the rest!

Use your no. 8 brush to paint the body and wing of the bird a light value of Cobalt Blue, keeping the chest, the belly of the bird and the white spot behind the eye the white of the paper. Once this wash is dry, paint the head, the back, and the inner part of the wing with a medium value of Aureolin, switching to your no. 4 brush for tight areas. Finally, paint the neck with a medium value of Permanent Rose.

3 Add the Middle Values

Use your no. 8 brush and a medium value of Winsor Green and Aureolin to paint the green patch under the wing. Soften the edges using a clean, damp brush. Mix a combination of Quinacridone Gold, Aureolin, Winsor Green and Cobalt Blue and with your no. 4 brush, paint the scalelike feathers on the head, allowing bits of the first yellow wash to show through. Use this same color combination to apply feather texture to the bird's back and the top, inside area of the wing. The feathers on a hummingbird's neck overlap each other, much like fish scales. Using your no. 4 brush, start to define this pattern on the neck, using Permanent Rose in a slightly darker value than you used in the previous step. Don't get too picky; you want only to suggest these feathers. Finally, with a medium mixture of Cobalt Blue and Permanent Rose, paint the wing again, allowing a little of the wash applied in the last step to show through, suggesting feather edges.

Marketing Your Bird Paintings

If you are interested in marketing your bird paintings, remember that some species sell better than others. People love bluebirds, cardinals, hummingbirds, quail and many more, but if the painting is a bird portrait, LBGs (little brown guys) are more difficult to sell .

4 Get a Little Darker

Use your no. 4 brush to define the neck feathers a little more with a darker value of Permanent Rose. Add some Alizarin Crimson as you work closer to the beak. Further define the feathers on the head, the back, and the inner part of the wing using a mix of Winsor Green, Quinacridone Gold, Raw Sienna and Cobalt Blue. Make sure you allow some of the previous layers to show through.

With a dark mixture of Winsor Green, Alizarin Crimson and French Ultramarine Blue, paint the beak and tail. Paint the wing again with a medium mixture of Cobalt Blue and Permanent Rose, but this time add a little Raw Sienna to the mixture. Darken the part of the wing that is closest to the body. Let a little of the previous washes show through. Finally, to make the body of the bird look rounder, paint a light value of Cobalt Blue along the edge of the white chest and belly. Using a clean, damp brush, soften the edge of the Cobalt Blue.

5 Give the Hummingbird Punch

Mix a little Winsor Green and French Ultramarine Blue into Alizarin Crimson to make a dark red. Use your no. 4 brush and this mixture to paint the detail below the beak and on the throat. When this is dry, add a bit of Dr. Martin's Bleed-Proof White to Permanent Rose and add lines of dots along the throat to replicate the feather pattern. With Winsor Green, a little Alizarin Crimson and Cobalt Blue, make a dark green that you can use on the head and body as the final dark value. When the head is dry, mix a little white with New Gamboge and put a row or two of little feather spots from the beak to above the eye.

With a fairly dark value of Cobalt Blue and Raw Sienna, add some little feather lines in the green patch on the side of the body. Use a darker mixture of Alizarin Crimson, Winsor Green and French Ultramarine Blue to add feather detail to the wing. Use a medium value of Cobalt Blue for feather lines on the white part of the hummingbird's body, especially close to the tail.

Check the hummingbird over. Have you missed anything? Oops, you need to darken under the tail with a wash of Cobalt Blue. The line where the rose-colored neck meets the body seems a little hard. Soften the edge with a few strokes of white. Don't forget to paint the feet with the dark combination of Winsor Green, Alizarin Crimson and French Ultramarine Blue.

The Gate Keeper
Watercolor on 300-lb. (640gsm) cold-pressed paper
9" × 13" (23cm × 33cm)
Private collection

Who doesn't love chickadees? They're cute and fun to paint. (The tit is a similar bird found in Europe.) As they're common at backyard feeders and in backyards, chickadees can be placed on a man-made object: a wheelbarrow, a garden faucet, a garden gate.

I like to use the strong lines on man-made objects to create strong compositions. a black-capped chickadee is only 5¼" (13cm), so make sure the scale of the bird to other objects is accurate.

Materials List

Surface
300-lb. (640gsm) cold-pressed paper

Paint
Alizarin Crimson ❖ Cobalt Blue
French Ultramarine Blue
Permanent Rose ❖ Quinacridone Sienna
Raw Sienna ❖ Winsor Blue
Winsor Green

Brushes
no. 8, no. 4 rounds

Other
2H pencil ❖ Kneaded eraser
Dr. Martin's Bleed-Proof White

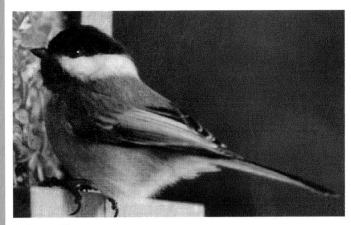

Reference Photo
This chickadee was facing the other way in my photograph. I scanned it into my computer using Photoshop, flipped the image, then printed it. You can do the same thing using a color copy machine at a copy center.

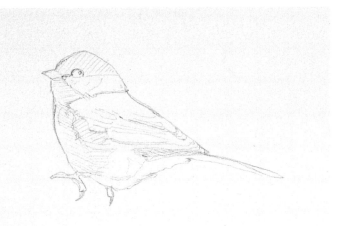

1 Complete the Drawing
Using a 2H pencil, do your drawing with more feather detail than you really need. The detail will help you understand the structure of the bird as you paint it, even if many areas are only suggested in the final painting.

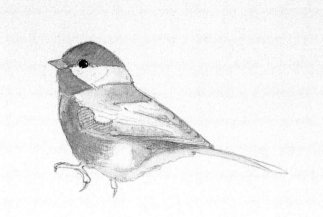

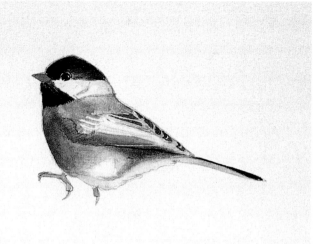

2 Apply the First Washes

Save the white of the paper for the chickadee's cheek and the back of the neck, some of the feathers in the wing and the lighter value below the wing. Now using your no. 4 brush, paint the head and neck with a pale value of Winsor Blue and Permanent Rose. Most of this purple wash will be covered later, but little bits will show through.

When the head is dry, paint the eye using a dark mixture of Alizarin Crimson, Winsor Green and French Ultramarine Blue. Leave a spot of white paper for the eye highlight.

Glaze the back down to the tail, the chest and the parts of the body below the wing with a light value of Raw Sienna and Quinacridone Sienna. With a light wash of Cobalt Blue and Raw Sienna, paint the white underparts, back to the tail. Finish this step with a little Cobalt Blue and Raw Sienna painted over the darker part of the wing.

3 Add the Middle Values

Using your no. 4 brush, paint the lower, darker part of the wing using a medium value of Cobalt Blue and a little Alizarin Crimson. Now with a pale value of Cobalt Blue and Raw Sienna, slightly darken the back of the chickadee's white neck, and add a little detail to the white cheek. With Raw Sienna and a little Cobalt Blue, paint some medium-value detail on the bird's back, between the white area and the top of the wings. Darken the area below the wing, where the body meets the undertail part with Raw Sienna and a little Cobalt Blue.

To paint the head and throat, mix a dark value of Winsor Blue and Alizarin Crimson. As you paint the head and throat, let a little of the purple undercolor show. Use this color on the top part of the tail also. Although a chickadee's head really isn't this deep reddish-blue color, the luminous colors are much more interesting than black.

Paint the dark values on the top part of the wing using a medium value of Quinacridone Sienna, Alizarin Crimson and French Ultramarine Blue. Make sure you leave the feather's edge the lighter value that you painted on the previous step.

The chickadee's chest is in shadow. Using a combination of Raw Sienna and Cobalt Blue, paint the medium values on the chest. Paint the white part of the tail with a medium-value Cobalt Blue. Using Winsor Blue and Alizarin Crimson, paint the beak a medium value. Paint the feet with a medium value of Cobalt Blue and Raw Sienna.

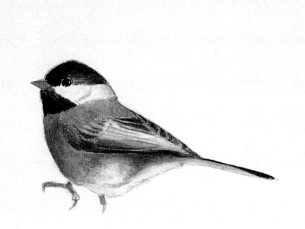

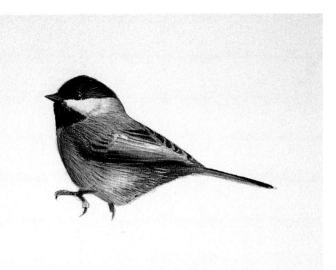

4 *Get a Little Darker*

In this step, you will start to darken the values and correct the color if needed. If the bird's back, wings or chest appear a little colorless, wash over the area with a light value of Raw Sienna. If you find you've made an area too dark, you can lighten the value by lifting color with a damp brush and paper towel.

Now let's work on the wing details. Use a medium-value Cobalt Blue to darken the lightest feathers in the middle of the wing. Keep some of the white paper for the feather's edge. Darken the bottom edge of the wing with Alizarin Crimson, Winsor Green and French Ultramarine Blue. Define some of the feathers where the back meets the wing using Cobalt Blue and Raw Sienna.

5 *Give the Chickadee Punch*

Darken parts of the head using Winsor Blue and Alizarin Crimson with a touch of Winsor Green. Add this dark mixture to the feet. Using Cobalt Blue, put a little feather detail on the white cheeks. Double-check your values on the rest of the bird and add darks where needed.

Using your no. 4 brush, add some fine white featherlike lines with Dr. Martin's Bleed-Proof White. Paint a few feather lines where the breast meets the wing. Using opaque white is effective if you don't overdo it. If you forgot to save a little white speck for the eye's highlight, use a spot of white paint.

Ladybug

Materials List

Surface
300-lb. (640gsm) cold-pressed paper

Paint
Alizarin Crimson ❖ Cobalt Blue
French Ultramarine Blue
New Gamboge ❖ Permanent Rose
Winsor Green

Brushes
no. 4 round

Other
2H pencil ❖ Kneaded eraser

1 Complete the Drawing
Use a field guide or magazine picture to understand how a ladybug is constructed, then using basic drawing skills, draw an oval and add a head, legs and spots. A ladybug is so small that accuracy in the fine detail isn't an issue.

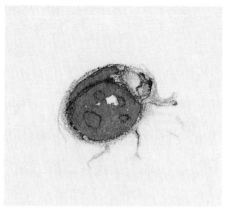

2 Add the Medium Values
Using your no. 4 brush, underpaint the body with a medium value of New Gamboge and Permanent Rose. Leave a little white spot of paper for a highlight. Wash over the ladybug's thorax with a little Cobalt Blue.

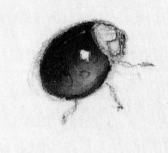

3 Add the Stronger Values
With your no. 4 brush, add a stronger value of New Gamboge and Permanent Rose to the top part of the body. Rinse your brush and touch it to a paper towel to remove the extra water. Now soften the edge of the New Gamboge-Permanent Rose brushstroke that you just applied. Add a little color to the bottom edge of the ladybug's back and soften the edge of the color with a damp brush.

4 Add the Darkest Values
If your no. 4 brush has a good point, you should be able to use it for even the finest detail on the ladybug. If the point isn't good, then replace the brush! Using a damp brush, soften the edges of the white highlight on the ladybug's back. Now mix a dark value of Alizarin Crimson, Winsor Green and French Ultramarine Blue. Paint the centerline that divides the back, thorax, legs and spots. Once the painting is completely dry, you can erase over the entire ladybug to remove the pencil lines.

Dragonfly

Materials List

Surface
300-lb. (640gsm) cold-pressed paper

Paint
Alizarin Crimson ❖ Cobalt Blue
French Ultramarine Blue
Permanent Rose ❖ Quinacridone Gold
Winsor Green

Brushes
no. 4, no. 2 rounds

Other
2H pencil ❖ Kneaded eraser

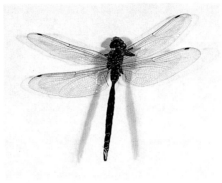

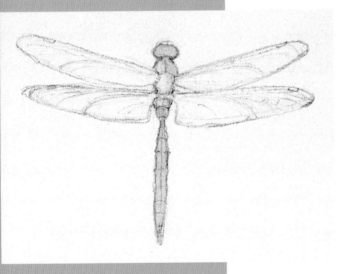

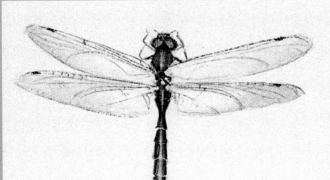

Reference

Dragonflies are difficult to photograph, so when one obligingly died in my garden, it became reference material for a painting. (Halfway through this painting I sat a teacup on this dragonfly and had to glue it back together to finish the painting.)

1 Complete the Drawing

Put in as much detail as you can see, but not necessarily all of the detail. Measuring the dragonfly's wings and body will help you get the proportions right.

2 Apply the Lightest Washes

There's not much to paint on a dragonfly, but the process is the same as painting a teacup or an elephant. Work light to dark, loose to tight. The first step will be to paint the abdomen (the long tail) a pale Cobalt Blue, using your no. 4 brush. Paint the thorax and head a pale mix of Cobalt Blue and Permanent Rose. Though the wings are transparent, they have a gold-brown cast. Paint the wings a very light value of Quinacridone Gold.

3 Add the Darkest Values

Repaint the abdomen with a medium-value combination of Cobalt Blue and a little Alizarin Crimson. Leave the centerline and the edge of each abdomen segment the pale value of Cobalt Blue that you painted in step 2.

Paint the thorax the same way, but add more Alizarin Crimson and less Cobalt Blue to the mix. Paint the head in the same manner but add a little Winsor Green to the mixture.

Use the tip of your no. 2 brush to paint the lines on the wings, but don't try to paint each line. You want the wings to look transparent. Paint only the larger, darker lines using a dark combination of Winsor Green, Alizarin Crimson and French Ultramarine Blue. Use this dark mixture to paint the legs and antennae. If you paint a dragonfly in a composition with other objects, remember that you will be able to see through the wings to the objects behind.

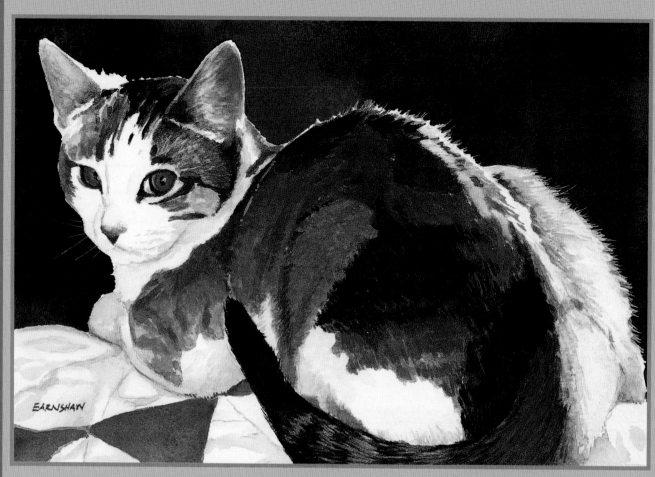

Joe's Cat
Watercolor on 300-lb. (640gsm) cold-pressed paper
5" × 8" (13cm × 20cm)
Collection of Mr. John Hoffman

Just the thought of painting a furry cat is intimidating. To complicate the issue, a cat is often patterned with stripes or spots. Simplify! Don't try to paint each hair. Paint the shapes produced by the masses of hair. Some clumps will catch the light and cast shadows, and some clumps will just be dark masses. This is where it will help to rely on your reference and to paint upside down.

Materials List

Surface
300-lb. (640gsm) cold-pressed paper

Paint
Alizarin Crimson ❖ Cobalt Blue
French Ultramarine Blue
New Gamboge ❖ Permanent Rose
Quinacridone Sienna ❖ Raw Sienna
Winsor Green

Brushes
no. 8, no. 4, no. 2 rounds

Other
2H pencil ❖ Kneaded eraser
Carpenter's square
Dr. Martin's Bleed-Proof White

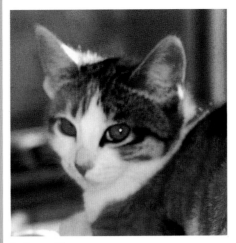

Reference Photo
Look at your reference upside down. Instead of seeing an ear, you'll see a gray triangle with a pink blob here and a white line there. It's much easier to duplicate the triangle than it is to paint an ear.

1 Complete the Drawing
Use a 2H pencil to draw lines or cross-hatching to indicate dark areas of pattern or shadow. Don't press too hard. Indentations in the paper will collect pigment and darken as the paper dries.

2 Apply the First Washes

Leave the white of the paper for the back of the left ear and most of the face and neck. Paint the second lightest value on the ears with a pale value of Permanent Rose, using your no. 8 brush. Paint the nose, the white of the right eye, above and below the right eye, and the left side of the left eye with the same value of Permanent Rose.

Once this is dry, underpaint all orange parts of the cat's face, the left edge of the right ear and the back of the neck with a light value of Quinacridone Sienna. Paint the little bit of the kitty's body with Quinacridone Sienna, but soften the edge with a damp brush so it transitions smoothly to the white paper without a hard edge. Underpaint the dark pattern of the kitty's face with a light value of Cobalt Blue and Raw Sienna.

3 Add the Middle Values

Mix Quinacridone Sienna and Permanent Rose and use your no. 8 brush to paint the pinky-orange of the ears. Soften the edges with a clean, damp brush.

Paint the chin with a light value of Permanent Rose and Cobalt Blue. When dry, paint the line from the mouth to below the cheek with a light value of Cobalt Blue, softening it.

Use a medium value of Quinacridone Sienna to start defining the middle values on the head above the left eye.

Paint the eyes with a Quinacridone Sienna-New Gamboge mix. Paint over the pupils, but leave the white of the paper for the eye's highlight.

Paint the middle value patterns over the cat's right eye using Raw Sienna, Cobalt Blue and a little Quinacridone Sienna.

Strengthen the values on the nose with Permanent Rose and a little Quinacridone Sienna.

4 Get Darker

The medium-to-dark values that you add in this step will start to give the cat some oomph! First, add a darker value of Quinacridone Sienna and Raw Sienna to the outer perimeter of the irises, using your no. 4 brush. Then with a damp brush, soften the edge toward the middle of the eye.

With your no. 8 brush and a mixture of French Ultramarine Blue, Raw Sienna and a little Alizarin Crimson, darken some of the forehead above the right eye. Darken the nose using Permanent Rose and New Gamboge. With Permanent Rose and Cobalt Blue, darken the chin and jaw just a little. Soften the edges. Use a dark mixture of Winsor Green, Alizarin Crimson and French Ultramarine Blue to paint the iris and outer perimeter of the eyes. Look at the reference photo and see if you need to darken anything before painting the final darks in the next step.

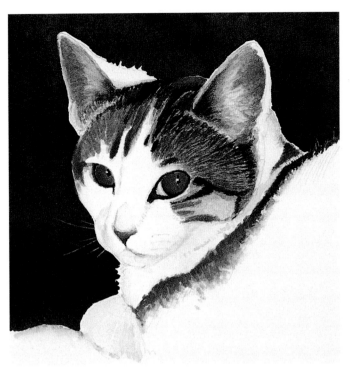

5 Paint the Darks and Details

Mix a combination of Alizarin Crimson, Winsor Green and French Ultramarine Blue. Then using your no. 4 brush, paint the dark stripes on the kitty's head. The stripes on the orange side of the head will be painted using Quinacridone Sienna and French Ultramarine Blue. You might find it easier to see the pattern if you work upside down. The pattern is painted using little brushstrokes. Don't worry about softening edges. If you've made an area too dark, you can lift a little using a damp brush and paper towel. If the head pattern looks too patchy, then once it is dry, wash over the area with a light value of the Quinacridone Sienna-Raw Sienna mixture.

Pay close attention to the eye detail on the reference. The left eye is rimmed with a darker value, in addition to the obvious rim on the right eye.

The ears are tricky. If they seem flat then darken the pinky-orange areas, cutting into the lighter-valued Permanent Rose-Cobalt Blue that you applied in step 3 to give the effect of the long hair in the ears.

You'll notice that the back of the left ear is still the white of the paper, so it disappears against the white background. And how do you define white kitty whiskers against white? By darkening the background! Use a carpenter's square to draw the perimeters of your background and I'll show you how to paint a dark, luminous background.

6 Paint the Background

Don't worry about painting neatly up to the penciled perimeter. A slightly sloppy edge is more interesting than a clean one. Mix a big puddle of French Ultramarine Blue and a separate puddle of Alizarin Crimson. Mix a smaller batch of Cobalt Blue. These three color puddles should be strong in value, so don't use too much water. You'll be doing the background on dry paper. Use your no. 8 brush. If you were painting a larger area, I would suggest using a no. 14 or even a no. 36 round. When painting around the cat, an irregular edge will suggest cat hair.

Once you are ready to paint you have to move quickly, so have everything you need right at hand. Work quickly but carefully. Start at the bottom left with a brush full of French Ultramarine Blue. Paint a few inches in French Ultramarine Blue, and then load your brush with Alizarin Crimson. It's OK if the brush has both colors on at once. Occasionally add a brushstroke of Cobalt Blue. Don't dawdle or you may end up with a hard dry edge. Work your way around the kitty. The dark background really adds punch!

Allow it to dry completely, then erase your pencil perimeter. If there are any edges that look too hard where the cat meets the background, use a damp no. 4 brush and gently blur the edge. Clean the brush, and blur it again. This is a good way to soften an edge. Finally, with Dr. Martin's Bleed-Proof White and your no. 2 brush, add fine lines for whiskers.

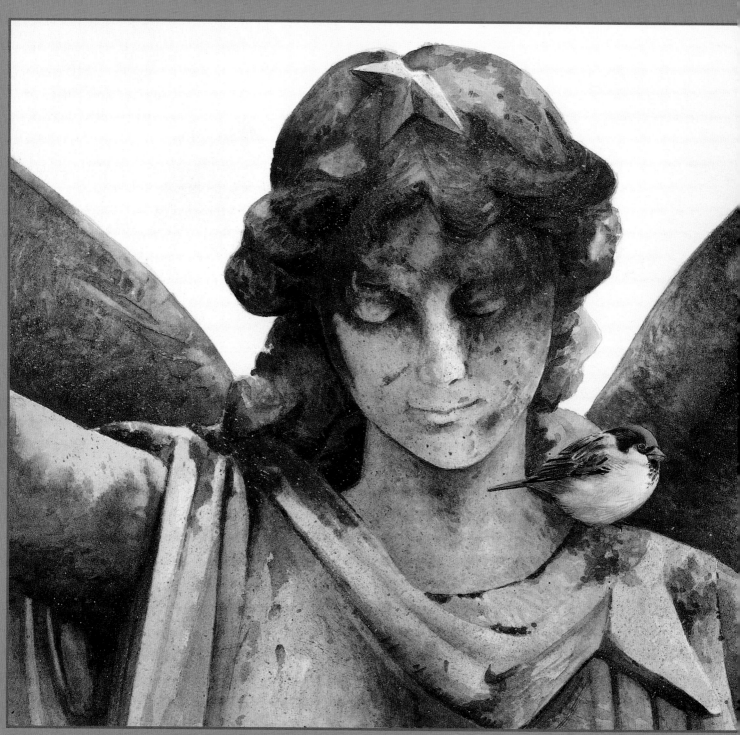

This statue has no strong light source. Texture and negative shapes help create an interesting composition. (See pages 100-105 for a demonstration of this painting.)

Putting It All *Together*

Moment of Silence
Watercolor on 300-lb. (640gsm) cold-pressed paper
12" × 19" (30cm × 48cm)
Collection of John and Darlene Schmitz

In the previous five chapters, we've discussed how to find ideas and how to design your compositions, and we've learned various watercolor techniques along the way. In this chapter, you'll learn, step by step, how to do more complex paintings. You can paint the subjects used in the demonstrations, or you can use your own props, applying the concepts of the demos. Whether you follow the steps for an entire painting or just part of one, I hope you find something that clicks; whether it is something simple, such as remembering to keep a paper towel in your other hand to take the extra moisture off the brush, or something more complex such as painting a teacup.

CHAPTER SIX

Besides being nostalgic, this painting will appeal to cat lovers! Cat owners know what it is like to pack a suitcase with a cat around. Take out the cat…put in a shirt…take out the cat…put in your socks…take out the cat, etc.

This is a rather complex design, but it should be fun to paint. Cropping in on the subject matter eliminates the problems that backgrounds present.

Materials List

Surface
300-lb. (640gsm) cold-pressed paper

Brushes
no. 36, no. 14, no. 8, no. 4 rounds

Paint
Alizarin Crimson ❖ Aureolin
Cobalt Blue ❖ French Ultramarine Blue
Genuine Rose Madder ❖ New Gamboge
Permanent Rose ❖ Quinacridone Sienna
Raw Sienna ❖ Winsor Blue
Winsor Green

Other
2H pencil ❖ Kneaded eraser
Dr. Martin's Bleed-Proof White

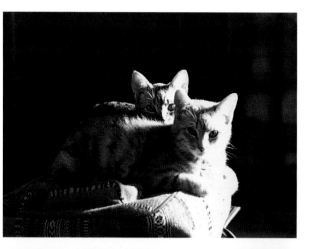

Pay Attention to the Direction of Light
Notice how the direction of light in this reference photo matches the light in the suitcase photos. Be aware of light direction when you combine reference photographs!

Pay Attention to Shape and Shadow
This wonderful old suitcase has gone many miles. I arranged the lace and linen to soften the shape of the very square suitcase. The lace was arranged so that it cast an interesting shadow.

Take Multiple Photographs
When photographing two objects, one light and one dark (as with these suitcases), the camera will expose for the lighter subject, thus making the dark subject too dark. You will get better references if you photograph each object separately.

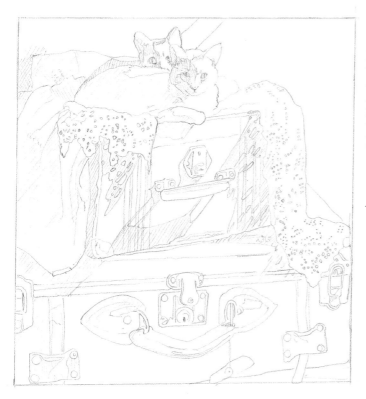

1 Complete the Drawing

When you do a complex drawing, use fine lines to define shadows to serve as landmarks as you paint. You can erase them when the painting is finished. Use a 2H pencil and a kneaded eraser. Working upside down will help you see shapes.

2 Establish the Underlying Colors

Use your no. 8 brush and a light value of Cobalt Blue to paint the shadow on the lace to the left of the cats.

Paint the linen cloth on the left side of the suitcase, saving the white spots on the edge of the linen as white paper. Use a light wash of Winsor Blue at the top and add Cobalt Blue as you work your way down. Add a little Permanent Rose in some areas. Paint the folded tablecloth behind the cats using a light value of Raw Sienna and Permanent Rose.

Use your no. 8 brush to paint the front of the top suitcase a light combination of Raw Sienna and Permanent Rose. Leave the almost-white edges of the suitcase unpainted for now.

Paint the shadows on the lace that hangs over the right side of the suitcase with pale Cobalt Blue. Don't paint the lace that is right next to the front cat yet.

Paint the top of the lower suitcase with a light-value mixture of Genuine Rose Madder and Cobalt Blue. After you paint this, add a brush-stroke or two of a Permanent Rose and Raw Sienna mixture into the wet paint on the front part of this case. Paint the front of the lower suitcase using Genuine Rose Madder and Cobalt Blue. Paint the latches and lock with New Gamboge and Raw Sienna. Paint the lock on the top suitcase with a mixture of Cobalt Blue and Permanent Rose. Use a Cobalt Blue-Alizarin Crimson mixture to paint the handle on this case. Save the white paper for the lightest value on the handle.

Paint the inside lid of the top suitcase with a light-value mixture of Raw Sienna and Permanent Rose. Use this same mix to paint the light values on the cats. Don't paint parts of the cat that must remain as white paper, but don't try to save white paper for the whiskers. Paint the front kitty from her tail to her head. Add Cobalt Blue to the Raw Sienna-Permanent Rose mixture for the back end of the cat, and then switch back to the Raw Sienna-Permanent Rose mixture for the front part and on the ears.

3 Paint the Medium Values

With your no. 8 brush and a mixture of Cobalt Blue and Permanent Rose, paint the medium values on the linen. Do not paint over all of the lighter values from step 2. Add more Cobalt Blue and less Permanent Rose and work toward the bottom of the cloth. Repeat this process with the lace using the same colors.

Repaint the front of the top suitcase using Permanent Rose, Aureolin and Raw Sienna. Add texture with the brushstrokes, letting some underlying value show through. Once this is dry, paint the stripes in a medium value of Cobalt Blue and Winsor Green. Use Aureolin for the thinner yellow stripes. The middle value on the lock is Cobalt Blue and Raw Sienna. Brush this lightly on dry paper to create a little texture.

Paint the locks and latches on the bottom suitcase with Aureolin and Cobalt Blue. There are teardrop-shaped pieces of leather where the handle attaches to the case. Wash over these with Winsor Blue and Permanent Rose, letting a little of the first wash show through.

With your no. 8 brush, use Permanent Rose and Raw Sienna for the front cat's orange stripes. Use Cobalt Blue and Raw Sienna for her gray stripes. Paint both cats' ears with a middle value of Permanent Rose and Raw Sienna. Allow the first wash to show in places. Paint the back cat's irises with Cobalt Blue and Aureolin. The front cat's eyes are bluer, so use more Cobalt Blue, less Aureolin. Paint this kitty's nose with Permanent Rose.

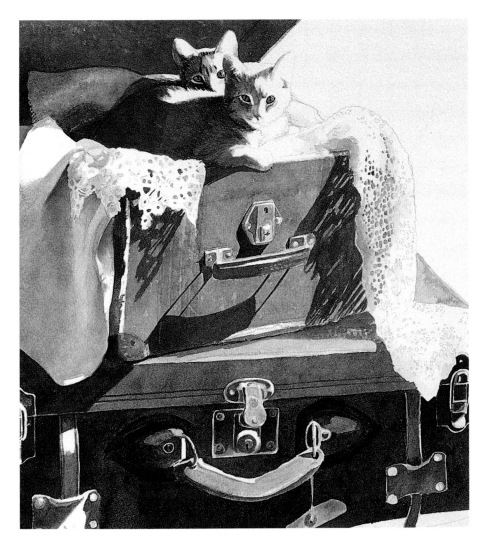

4 *Go Even Darker*

Use your no. 8 brush to paint the medium-dark values on the linen to the left of the cats using Cobalt Blue and a little Permanent Rose. Work on the lace in the same manner, switching to your no. 4 brush for tight areas. Paint the holes of the lace with Raw Sienna and Permanent Rose, varying the mix as you move around the lace.

Paint the darker values on the suitcase locks and latches using Aureolin and Cobalt Blue. Use your no. 8 brush and an Alizarin Crimson-Cobalt Blue mixture to paint the shadow cast by the lace on the lower suitcase and where the two suitcases meet. To add texture, drag the brush over the lower suitcase's lid to the right of the lace.

Paint the stripes on the top suitcase, using a dry brush for texture and a medium value of Raw Sienna with a tiny bit of Aureolin. Paint the yellow stripes with Aureolin using drybrush texture. Paint the inside lid of the top suitcase with a darker medium value of Raw Sienna and Permanent Rose, making it darker around the cats. Once this area is dry, darken the cloth behind the cats using a mix of Raw Sienna and Cobalt Blue.

Starting with the back kitty, use your no. 8 brush to define the darker areas with a mix of Cobalt Blue and Quinacridone Sienna. Use your no. 4 brush and Aureolin with Cobalt Blue for the darker values of the cats' irises. Mix a dark value from Alizarin Crimson, Winsor Green and Quinacridone Sienna to paint the dark pattern on the face.

Paint the body of the front cat with a mixture of Raw Sienna, Permanent Rose and Cobalt Blue. Use less Cobalt Blue for the orange parts.

Use your no. 8 brush and a medium-dark combination of French Ultramarine Blue and Quinacridone Sienna for the dark shadow on the left side of the top suitcase. Use Quinacridone Sienna to add splotches of color to the front of the top suitcase for texture. Now mix a big puddle of a dark value of French Ultramarine Blue, Raw Sienna and Alizarin Crimson, and with your no. 14 brush, paint the front of the large suitcase. Work quickly on dry paper, not allowing the edges to dry. It doesn't matter if this wash isn't smooth and perfect. A slightly imperfect wash will add texture.

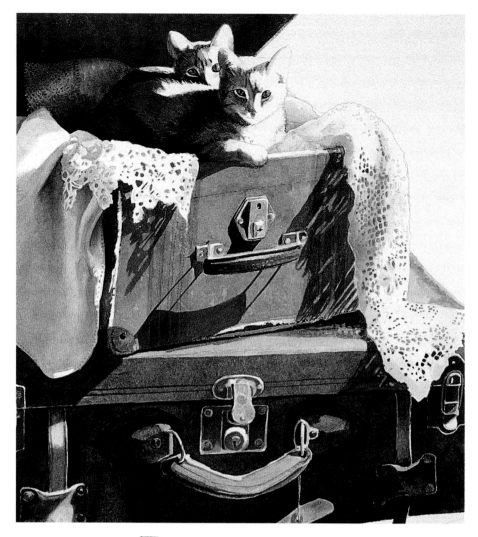

5 Define and Darken

When the front of the top suitcase dries, use a dark mixture of French Ultramarine Blue, Raw Sienna and Alizarin Crimson to paint the shadows on the suitcase. Use your no. 8 brush for the larger shadows, but switch to your no. 4 for the shadows cast by the lace. Using this same mixture, paint some of the darker values on the suitcase latches and straps.

Now paint the darker stripes on the kitty in the front using Alizarin Crimson, Winsor Green and Cobalt Blue. Use your no. 8 brush and make short strokes that follow the direction that the hair grows.

For the suitcase lid behind the kitties, use a dark mixture of Alizarin Crimson, Winsor Green and French Ultramarine Blue to darken this area. Now with Raw Sienna, Permanent Rose and Cobalt Blue, paint in short, fat strokes that angle every which way to add more value to the lid as you move toward the top of the painting. Allow underlying values to show through. This is why you are working in layers. Use the same technique for the lid edge on the bottom suitcase.

Darken the stripes on the suitcase that are in shadow with Winsor Green and Cobalt Blue. Work your way around the painting, defining areas and darkening values.

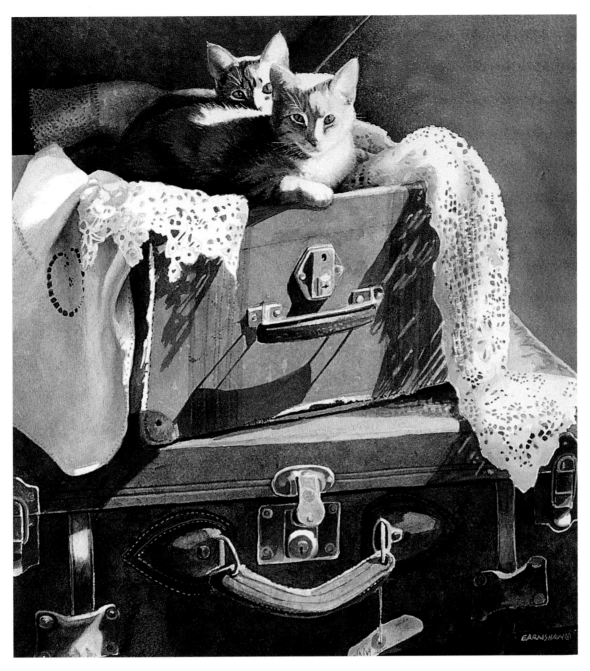

Day Trippers
Watercolor on 300-lb.
 (640gsm) cold-pressed
 paper
15" × 13" (38cm × 33cm)
Private collection

6 Add the Final Touches

Look at the linen that hangs out of the top suitcase. Are the blues blue enough? If not, glaze the linen with Cobalt Blue. Once dry, mix a very dark value of Winsor Green, French Ultramarine Blue and Alizarin Crimson to paint the holes in the linen. Use a damp no. 4 brush and lift a lighter line on the bottom edge of each dark groove that runs along the top lid of the lower suitcase. Lift and blot with a paper towel.

Mix a little Dr. Martin's Bleed-Proof White into Cobalt Blue for the suitcase stitches. Use straight white for whiskers and eye highlights. Use a little white to define areas on the lace that drapes over the right side of the top suitcase. Just a little is effective; too much will give your painting a chalky look.

Use your no. 8 brush to paint the negative space around the kitties, then switch to your no. 36 brush as you move away from the tight areas. Paint the area closest to the kitties with a mix of Alizarin Crimson, Raw Sienna and French Ultramarine Blue. Change to Cobalt Blue as you move toward the right edge of the paper and the suitcases.

After this is dry, use Cobalt Blue, Permanent Rose and Raw Sienna to paint the shadowed part of the linen. If needed, use a tiny bit of white to show the edge of the cat's chest against the linen. Don't worry about detailing the sunlit side of the cats' faces.

Statue and Sparrow

Watercolor is a wonderful medium to create the texture of stone. Drybrush techniques, splattering and glazing are tools you can use to create the colorful texture. That's part of the fun of painting a piece like this.

Materials List

Surface
300-lb. (640gsm) cold-pressed paper

Brushes
no. 36, no. 14, no. 8, no. 4 rounds

Paint
Alizarin Crimson ❖ Cobalt Blue
French Ultramarine Blue
New Gamboge ❖ Permanent Rose
Quinacridone Sienna ❖ Raw Sienna
Viridian Green ❖ Winsor Green

Other
2H pencil ❖ Kneaded eraser
Dr. Martin's Bleed-Proof White
Toothbrush ❖ Sandpaper
Tracing paper (optional)

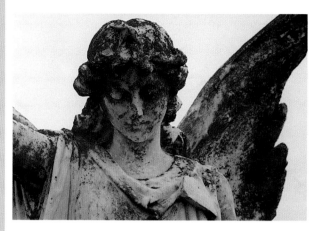

Statue Photo Reference
This statue has no strong light source, so we'll use texture and negative shapes to create an interesting composition.

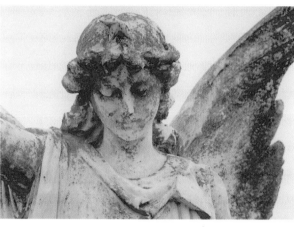

Statue Value Reference
A halftone copy from a color copier will help you understand the lights and darks of the statue.

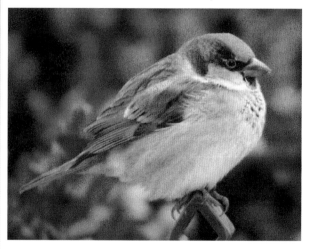

Sparrow Photo Reference
The sparrow in this reference photo faced the other direction. I scanned it into my computer and flipped the image using Adobe Photoshop. This can also be done on a color copier.

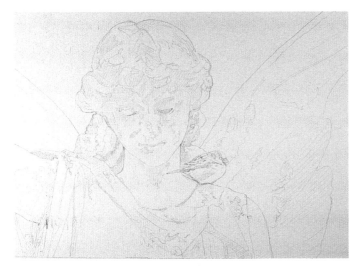

1 Complete the Drawing

Remember that your reference photos are only for reference. The more you paint, the more confident you'll be in making changes. In this drawing, I've made the composition more interesting by raising the statue's left wing. To do this, trace the right wing and then flip it. Draw lightly and erase carefully, using a kneaded eraser.

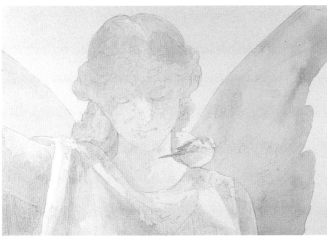

2 Establish the Underlying Colors

Save the white of the paper for the triangular shape on the angel's right bodice and the sleeve folds on the outstretched arm. Mix some large, light-value puddles on your palette. Some of the combinations you can use are: Raw Sienna and Permanent Rose, Cobalt Blue and a little Permanent Rose, Cobalt Blue and a little Alizarin Crimson. Paint the statue with these color mixtures and your no. 36 brush. Keep the cooler mix of Cobalt Blue and a little Permanent Rose on the left side of the head, the base of the right wing and the bodice. As you put color down, use a crumpled, soft paper towel to lightly blot some areas. This adds a little texture.

While the statue is damp, add a light value of Viridian Green in a few select places, blotting as you go. Do the same with Permanent Rose and then a mixture of New Gamboge and Permanent Rose. This builds color and texture.

Switch to your no. 8 brush and paint the sparrow. Use a light value of Permanent Rose for the breast, and a mixture of Permanent Rose and Raw Sienna for the bird's back. You won't work on the sparrow again until the last step.

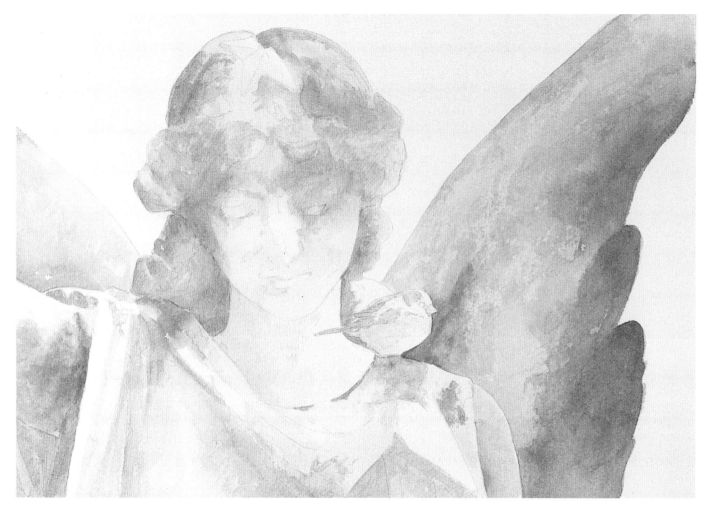

3 *Deepen the Color*

Start at the lower left, under the angel's arm. Use a medium-light mix of Cobalt Blue and Permanent Rose and your no. 8 brush. Leave the lighter folds unpainted. With a combination of New Gamboge and Permanent Rose, paint the lichen on the uplifted arm. As you add this color, soften edges with a clean, damp brush. Use this combination for the orange lichen on other parts of the statue, too. Be bold, but keep a paper towel in your other hand to lightly blot the color if it is too strong. Work your way around the statue, applying medium-light values. After you paint an area, dip a clean brush into water and add a few drops to the freshly painted area for texture. Create more texture by dragging the side of the brush across the dry painting. Work your way around the statue a second time, using the same colors to add another layer of texture and color.

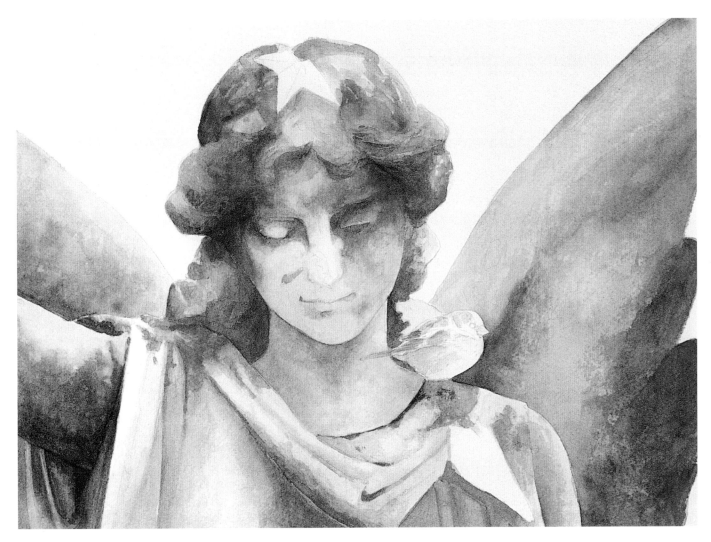

4 Paint the Middle Values

Use Cobalt Blue and Permanent Rose to establish folds on the angel's gown, and New Gamboge and Permanent Rose for the lichen color.

Work your way around the painting, darkening values and adding texture and color using the same colors from step 3. Paint a thin glaze of Viridian Green and Cobalt Blue over the face and neck to unify all of the layers and brushstrokes.

Once the paint is dry, very lightly sand parts of the statue with fine sandpaper, or scratch the surface of the paper lightly with a craft knife or single-edged razor blade to create texture. Don't overdo this. Just a little texture helps make the statue look like it's made of stone.

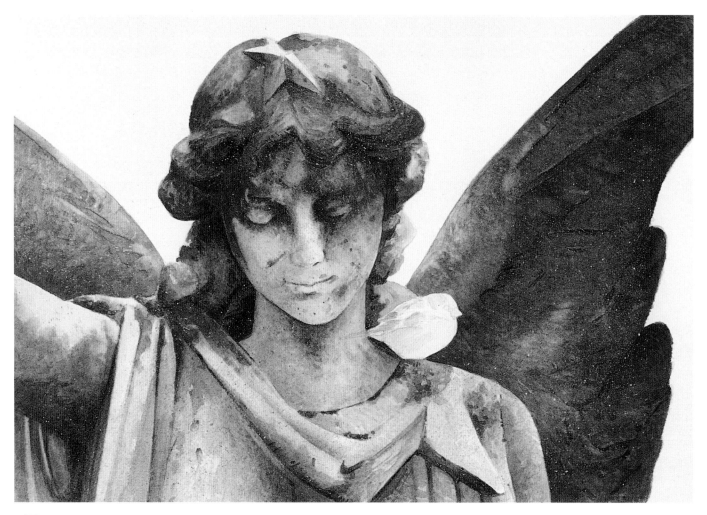

5 Define the Darks and Details

Mix Raw Sienna, Alizarin Crimson and French Ultramarine Blue (with blue as the predominant color) to define the darker areas of the head and wings with short, fat brushstrokes, using your no. 8 brush. Angle the strokes to look like chisel marks. You'll find it's an effective way of covering an area while creating texture. Use the same technique with the combination of Permanent Rose and New Gamboge, and then Cobalt Blue with Permanent Rose as you work your way around the statue. Add highlights by lifting. To make sure the light edge of the upraised arm doesn't get lost against the wing, keep the edge of the arm light and darken the wing behind it.

When you work on the wings, switch to your no. 14 brush and use short brushstrokes for texture. To make the wings look feathered, make scallop shapes with short brushstrokes to suggest the short feathers that line the part of the wing that is closest to the body. Longer lines suggest the flight feathers. Just a little feather definition is all that is needed. Don't paint the wing all one color. Use all of your different color combinations: Permanent Rose-New Gamboge, Cobalt Blue-Permanent Rose, Raw Sienna-French Ultramarine Blue-Alizarin Crimson. Continue texture off the gown and onto the arm to help make the angel look like a statue. If you find the short brushstrokes look too busy, soften them with a damp brush, or glaze over them with a unifying color such as a light value of Cobalt Blue.

Use an old, soft toothbrush loaded with a medium value of Cobalt Blue for spattering. Add opaque white to the Cobalt Blue and spatter over the entire statue.

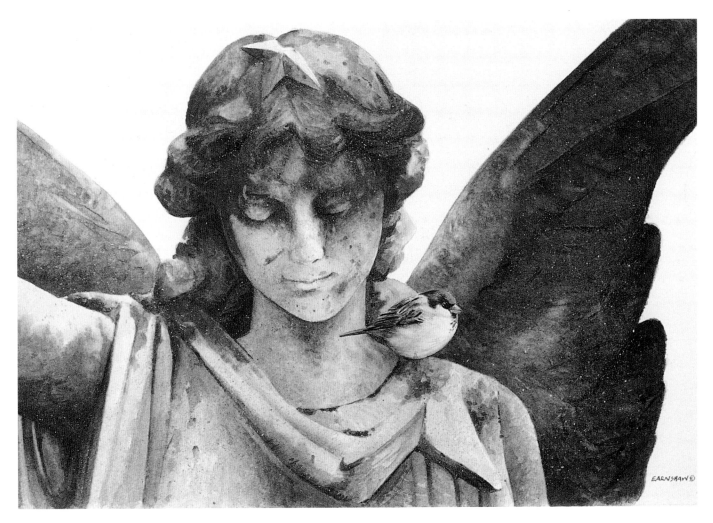

6 Finish the Sparrow

With a damp brush, scrub the bird lightly to remove any accidental spatters. Lift a little paint at the edge of the bird, especially under the tail and along the line of the chest. This will get rid of the harder outline that formed as you painted the statue.

Paint a medium value of Raw Sienna and Permanent Rose over the bottom back of the bird. Use your no. 4 brush and a medium value of Quinacridone Sienna to define the wing feathers. Paint the tail with a medium value of Cobalt Blue and Permanent Rose. There's a little white edge between the chest and side of the neck. Paint under the white edge using Cobalt Blue.

Now paint below the eye with a light gray value made with Cobalt Blue, Permanent Rose and Raw Sienna. Paint the head with the same mixture. When this is dry, paint the eye with a dark value of Winsor Green, Alizarin Crimson and French Ultramarine Blue, leaving a speck of white paper as a highlight. Paint the dark shape between the eye and beak, and a little spot behind the eye. Make a warm medium-value brown using Alizarin Crimson, Raw Sienna and Cobalt Blue.

Once the back end and tail of the bird are finished and dry, glaze over this area with a medium value of Cobalt Blue. This will cause the back end of the bird to recede a little, making the front part more prominent. Finally, add a few dark lines to suggest feet.

The angel stands out starkly on the white paper, but you can add a background if you like. If you do, keep it light in value so that it doesn't diminish the values on the angel. Step 6 of the next demonstration (page 111) will explain how to do this.

Moment of Silence
Watercolor on 300-lb. (640gsm) cold-pressed paper
12" × 19" (30cm × 48cm)
Collection of John and Darlene Schmitz

Cardinal and Quilt

Painting a sunlit quilt allows you to show the beauty of transparent watercolor. Coloring all of the shadows and folds before painting the quilt pattern makes this a fairly easy piece to create.

Materials List

Surface
300-lb. (640gsm) cold-pressed paper

Brushes
no. 36, no. 14, no. 8, no. 4 rounds

Paint
Alizarin Crimson ❖ Cobalt Blue
French Ultramarine Blue
New Gamboge ❖ Permanent Rose
Quinacridone Sienna ❖ Raw Sienna
Spectrum Red Gouache ❖ Winsor Green

Other
2H pencil ❖ Kneaded eraser
Dr. Martin's Bleed-Proof White

Cardinal Reference Photo
I'm using my own female cardinal photograph as reference, but changing it to a male. You can use a magazine photograph or a bird guide for color reference, providing you don't violate someone's copyright by reproducing his or her photograph.

Quilt Reference Photo
When you photograph a quilt, bunch it slightly on the line. Side lighting will exaggerate the folds.

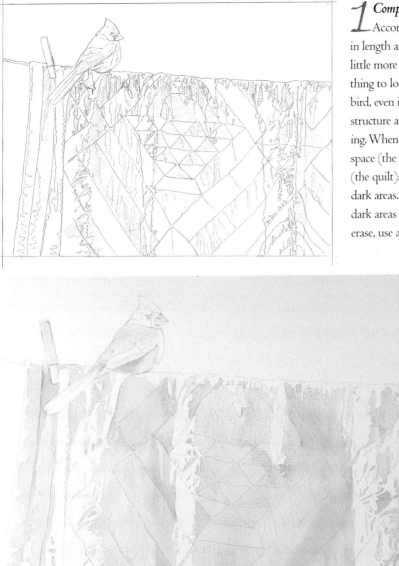

1 Complete the Drawing

According to my bird guide, a cardinal measures 8¾ inches (22cm) in length and a clothespin is 3½ inches (9cm), so draw your cardinal a little more than twice the length of the clothespin. Give the bird something to look at by facing it into the image. Put a lot of detail in the bird, even if you don't paint it later. This will allow you to see the bird's structure and important features, such as the wing, while you are painting. When you plan the layout of the quilt, don't forget that the negative space (the area around the quilt) is as important as the positive space (the quilt). Don't just draw the quilt pattern, but also show the light and dark areas. All these pencil lines will be less confusing if you mark the dark areas with fine lines before you start painting them. If you must erase, use a kneaded eraser.

2 Establish the Underlying Colors

It's very important that you save the white of the paper for the lightest value. This will give your painting the feeling that the quilt is sunlit. For the shadows, use your no. 14 brush and a little Cobalt Blue, then switch to Permanent Rose or Raw Sienna, thus working your way around the quilt. Paint the shadows right over the sketched quilt pattern. Keep the cooler blue in the deeper folds and use either Raw Sienna or a mixture of New Gamboge and Permanent Rose for the top of the folds. You also can use combinations of Permanent Rose and Raw Sienna, or Cobalt Blue and Permanent Rose. If you paint an area too dark, blot it with a soft paper towel to lighten the value. The larger brush prevents you from getting too picky at this time.

With your no. 8 brush, paint the back of the cardinal and the area below the wing and tail with a light-value mixture of Cobalt Blue and Permanent Rose. Paint the beak with a very pale value of New Gamboge. Paint the clothespin with a light value of Raw Sienna.

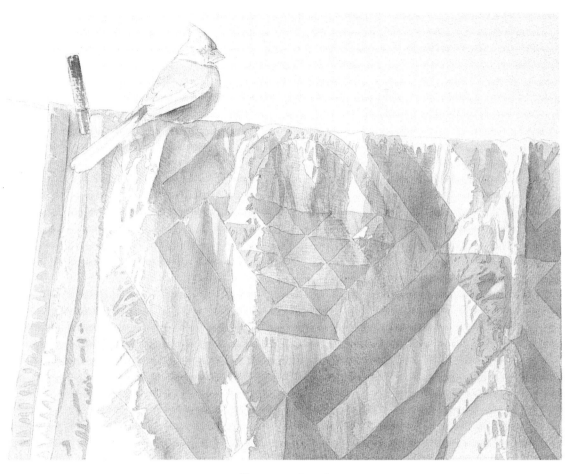

3 Deepen the Color

With your no. 8 brush, darken the folds in the quilt using the same colors (Cobalt Blue, Permanent Rose, Raw Sienna and New Gamboge) that you used in the last step, but in a slightly darker value. Don't get too detailed. Now paint all of the quilt pattern a light Cobalt Blue.

Continuing with your no. 8 brush, paint the right side of the cardinal with a medium wash of Cobalt Blue and Permanent Rose. Use a mixture of Quinacridone Sienna and Raw Sienna to add medium values to the clothespin with drybrush technique, adding texture but allowing a lot of the underpainting to show through.

Use a medium value of Cobalt Blue to add the cardinal's shadow on the quilt. Don't forget to paint the shadow cast by the tail.

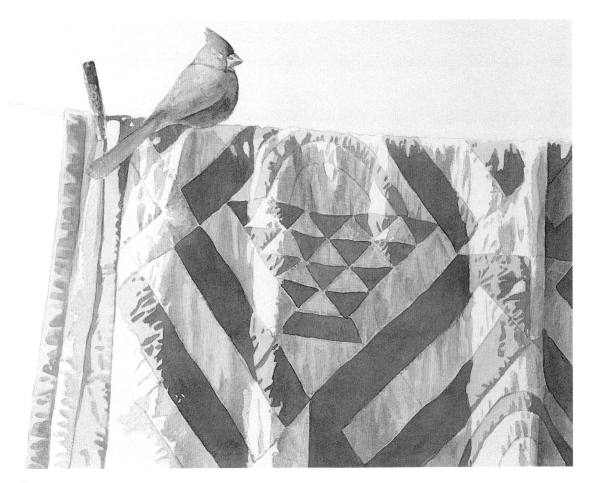

4 Paint the Middle Values

Use your no. 8 brush to paint a medium-dark value of pure
Cobalt Blue on the quilt pattern that is in shadow. Paint a little Perma-
nent Rose with Cobalt Blue in the shadowed white areas of the quilt to
build up the folds. Switch to your no. 4 brush to do the more detailed
puckers and seams. When the detail on the part of the quilt without the
blue pattern is dry, brush a light value of New Gamboge and Permanent
Rose over the tops of some of the folds to add warmth.

Wash a medium value of pure Alizarin Crimson over all but the back
of the cardinal. Paint the back with a little Cobalt Blue mixed into the
Alizarin Crimson, allowing parts of the earlier wash to show through.
Darken the clothespin a little more using a drybrush technique with a
reddish-brown combination of Quinacridone Sienna and Cobalt Blue.

Paint the medium values on the bird's beak with a mixture of New
Gamboge and Permanent Rose.

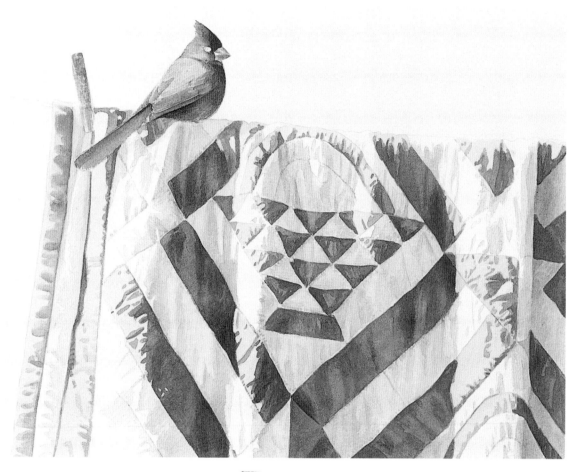

5 Define the Darks and Details

With a dark-blue mixture of Cobalt Blue, Alizarin Crimson and Raw Sienna, paint the darks on the quilt pattern.

Allow some of the previous values to show through. Double-check the part of the quilt without the basket pattern. This is the time to add the final darks to the quilt.

Use a darker mixture of Alizarin Crimson and a little Cobalt Blue to define the medium darks on the cardinal: the wings, the breast, the front of the head and the tail. Define the beak a little more with a little Cobalt Blue at the top and a wash of New Gamboge midway down.

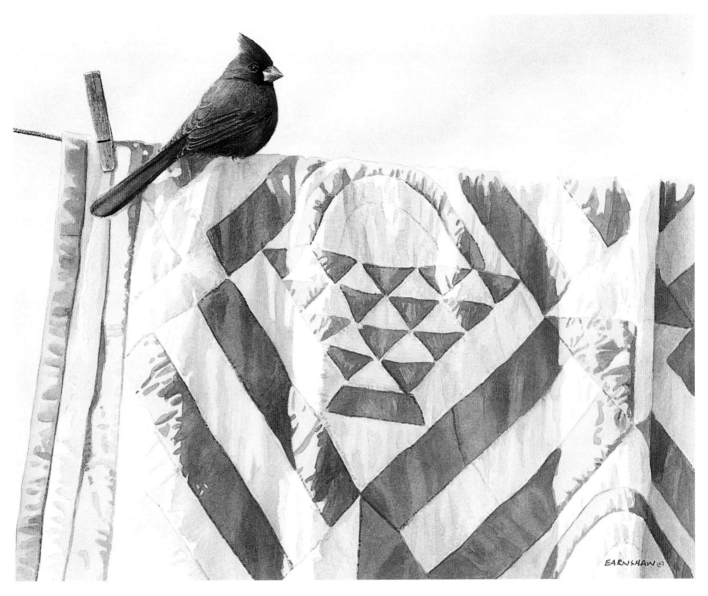

6 Give the Painting Punch

Use your no. 4 brush and a mixture of French Ultramarine Blue and Raw Sienna to tone down the bright blue of the quilt.

With a very dark mix of Alizarin Crimson, Winsor Green and French Ultramarine Blue, paint the metal part and a few little lines and dots on the clothespin. Darken the right side with Quinacridone Sienna and Cobalt Blue. Then, with Cobalt Blue and a little Raw Sienna, paint a darker line under and to the right of the clothespin to suggest shadow.

Paint the cardinal's eyelid with Raw Sienna. When dry, paint the eye and mask with a mix of Winsor Green, Alizarin Crimson and French Ultramarine Blue. When dry, mix French Ultramarine Blue with Dr. Martin's Bleed-Proof White and paint the area at the top left of the eye. When dry, add a tiny spot of white as a highlight.

Suggest feather detail on the chest, head and tail with Spectrum Red. Mix a little red with French Ultramarine Blue and paint under the wings and on the breast.

Mix Cobalt Blue into Alizarin Crimson to suggest feather detail on the cardinal's back, using short strokes. Keep these areas lighter in value, as this part of the bird is in direct sunlight. Mix a darker value of Alizarin Crimson-Cobalt Blue to define the darks on the wings. The cardinal may reflect a little color on the quilt, so wash a light value of Permanent Rose below and to the right of the bird.

Using your no. 36 brush, paint clean water over the background. Switch to your no. 4 brush as you near the quilt and bird. While wet, add a Permanent Rose-Cobalt Blue mix to the sky. Don't overdo it! Keep your paper completely flat as it dries. When dry, paint the clothesline using your no. 4 brush and Raw Sienna. Paint diagonal lines on the line in a darker value and darken the bottom edge of the line.

When the Wind Blows
Watercolor on 300-lb. (640gsm) cold-pressed paper
13" × 17" (33cm × 43cm)
Private collection

Geraniums are a popular and nostalgic flower. They are a good flower to paint if you are interested in selling your work. Adding a bird to the composition helps create more interest.

Materials List

Surface
300-lb. (640gsm) cold-pressed paper

Paint
Alizarin Crimson ❖ Aureolin
Cobalt Blue ❖ French Ultramarine Blue
New Gamboge ❖ Permanent Rose
Quinacridone Sienna ❖ Raw Sienna
Spectrum Red ❖ Winsor Green

Brushes
no. 36, no. 8, no. 4 rounds
Fritch scrubber

Other
2H pencil ❖ Kneaded eraser
Dr. Martin's Bleed-Proof White

Hummingbird Reference Photo
The hummingbird in the painting is a composite from several reference photographs. I started with this bird, then changed the wings and tail.

Flower Reference Photo
Some areas of this reference photo are too busy. You'll notice that I've simplified the design in the drawing by eliminating some leaves and moving other elements around.

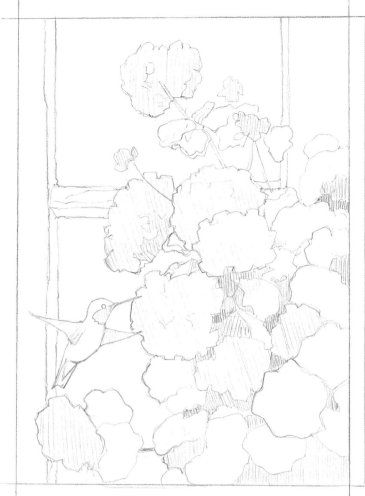

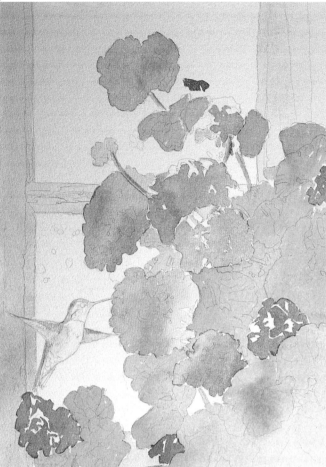

1 Complete the Drawing

Pay attention to the placement of the bird, keeping him visible against the busy flowers. Simplify the geraniums by moving leaves around and eliminating some flowers. Mark the flowers with fine lines to indicate darker values so the drawing is less confusing. If you erase, use only a kneaded eraser.

2 Establish the Underlying Colors

Paint all the leaves and stems with a pale wash of Aureolin using your no. 8 brush. When the leaves are dry, paint the flowers with a very pale wash of Alizarin Crimson. Leave the white of the paper for the lightest value on the flowers.

Paint the lightest values on the window frame with a light-value mixture of Cobalt Blue and Permanent Rose, keeping the mixture pinker at the bottom and bluer as you move up the window. Add a little Raw Sienna here and there.

Paint the back, head and sides of the hummingbird with a light-value wash of Aureolin using your no. 8 brush. Wash a little Cobalt Blue on the wings and body of the bird.

3 Deepen the Color

Use your no. 8 brush and various medium-value mixtures of Aureolin, Raw Sienna, Cobalt Blue and Winsor Green to paint the leaves varied colors. Make sure that you don't paint over the parts of the leaves that are to remain the lightest value of Aureolin that you painted in step 2.

Paint the geraniums exactly the same way, using a medium wash of Alizarin Crimson. Let bits of the lighter value show.

Use your no. 4 brush to paint the flower stems with a light-value combination of New Gamboge and Permanent Rose.

Use your no. 8 brush and Spectrum Red to add medium values to the flowers. Leave a little of the underlying values showing.

Define the feather pattern on the hummingbird's head and back by painting little scallops with your no. 4 brush and a medium-value mixture of New Gamboge and Winsor Green. Use a medium value of Cobalt Blue to loosely define the wing feathers.

Use your no. 8 brush and Cobalt Blue to add some drybrush texture to the window frame. This is a great technique for simulating wood.

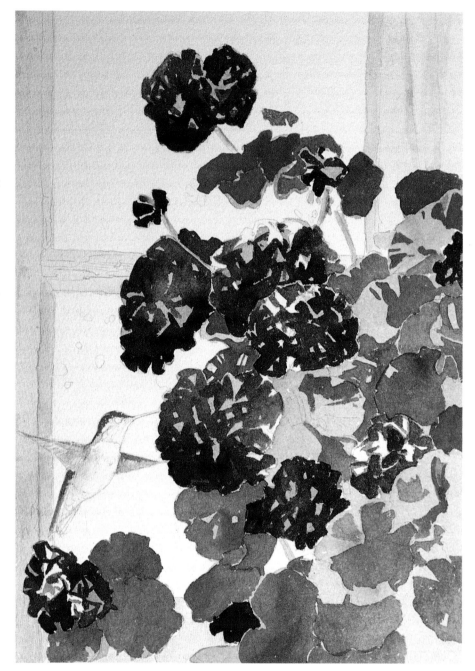

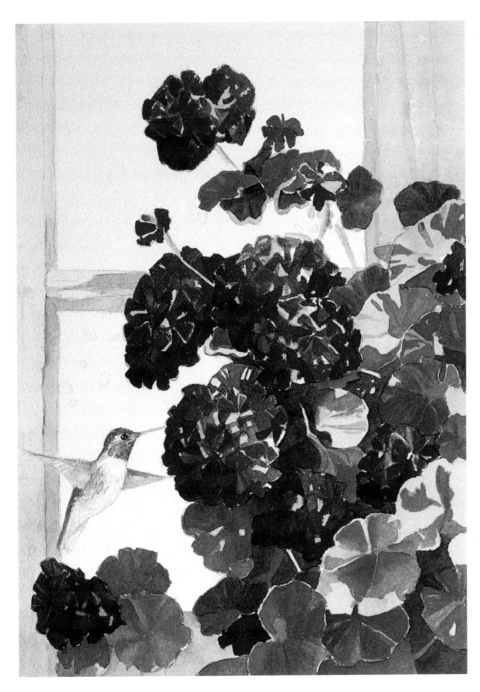

4 Paint the Middle Values

Paint the window frame with your no. 8 brush and a light value of Permanent Rose and Cobalt Blue. Make the mixture primarily Permanent Rose where the geraniums are reflecting color on the bottom part of the window frame, using more blue as you move up the window. Use a light wash of Raw Sienna for the upper part of the window. Let the colors blend into each other.

When you paint the flowers, it will help if you have an actual flower or close-up photographs of geranium flowers to help you understand the structure. With your no. 8 brush, use Spectrum Red to paint the medium darks on the flowers. Don't get too picky. Merely suggest the shapes of the petals.

Paint the leaves the same way you did the petals, but use a medium-dark mixture of Aureolin, Winsor Green and Cobalt Blue. Glaze some of the negative shapes between the leaves, using Cobalt Blue and your no. 8 brush.

With your no. 4 brush, add some medium-dark values to the hummingbird using Aureolin and Winsor Green. Use Cobalt Blue and Aureolin to add some feather definition under the wing. Paint the eye with a mixture of Winsor Green and Alizarin Crimson. Leave a spot of white paper for the highlight. Paint the neck with a medium value of Permanent Rose.

5 Define the Darks and Details

Use your no. 8 brush and a dark value of Spectrum Red and French Ultramarine Blue to paint the darkest reds in the flowers. Flowers that are overlapped by other flowers or leaves will be darker. When the flowers are dry, if they seem too dark you can lift little areas by scrubbing with a damp Fritch scrubber, then blotting with a paper towel. You can also use this technique to lighten areas that need a highlight.

Paint the darkest green on the leaves using your no. 8 brush and a dark value of Aureolin, French Ultramarine Blue and just a touch of Winsor Green. Add more French Ultramarine Blue to the mixture, and paint some of the darks between the leaves. When dry, try glazing over groups of leaves with a light wash of Aureolin to unite areas that look patchy. Paint the brown pattern on the leaves with a warm brown mixture using Alizarin Crimson, Quinacridone Sienna and a little Cobalt Blue.

With your no. 4 brush, paint the neck of the hummingbird using a medium-dark combination of Alizarin Crimson and Permanent Rose. Darken the values on the bird's body with a mixture of Aureolin and Cobalt Blue. Paint the wings with Cobalt Blue and Permanent Rose. Paint a little feather detail under the wings and toward the belly with Aureolin and Cobalt Blue, making it bluer as you work toward the belly and tail.

With your no. 36 brush, mix a medium value of Cobalt Blue, Permanent Rose and Raw Sienna and add value and texture to the window frame by dragging the brush across the dry paper, allowing underlying washes to show through. As you work your way around the window frame, change the ratios of blue, rose and sienna.

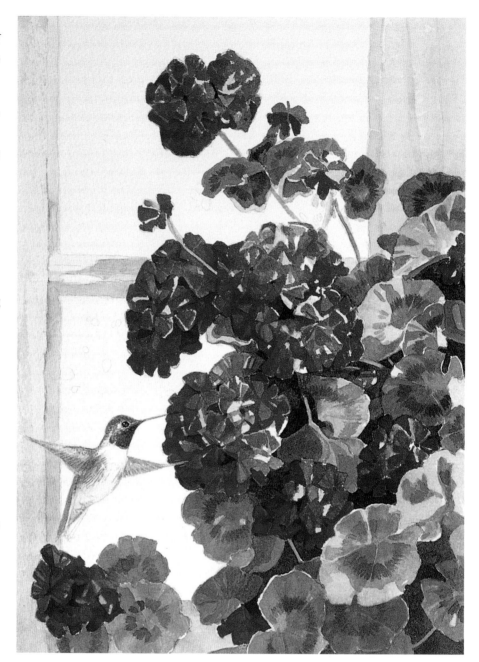

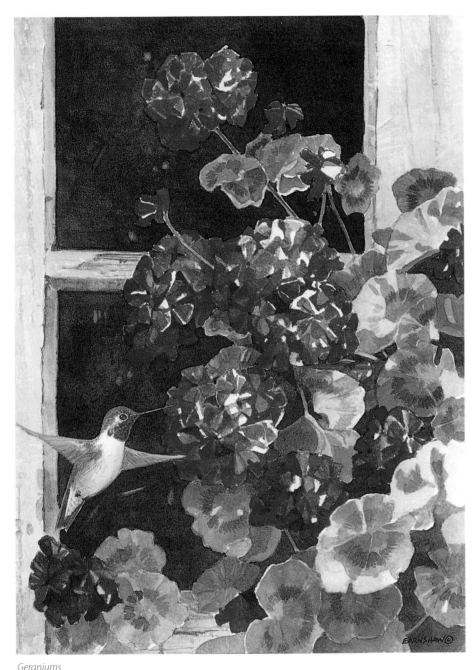

6 Paint the Darkest Darks

Mix a rich, dark combination of Alizarin Crimson and Winsor Green and paint the windowpane with your no. 8 brush in the larger areas, and your no. 4 brush for the smaller spots between the flowers and leaves. Start at the bottom left, and paint quickly so that edges don't have a chance to dry. Paint right over the hummingbird's beak for now. To suggest a flower reflection, paint a spot of pure Alizarin Crimson, bleeding it into your Alizarin Crimson-Winsor Green mixture. As you move up the window, add French Ultramarine Blue to your dark mixture. Don't worry if your darks are a little irregular. The windowpanes are reflective and don't have to be a perfectly smooth surface.

Sometimes where the flowers, hummingbird or window frame meet the dark panes, the edges may look too harsh. Once the painting is dry, use a clean, damp brush and soften these hard edges, slightly blurring the line between the dark panes and window or geraniums.

Work your way around the painting, adding the final darks. If you need to add a little opaque color, mix Dr. Martin's Bleed-Proof White into your paint now—but don't overdo it. Paint the flower stems using a combination of Permanent Rose and New Gamboge. Mix a little Dr. Martin's Bleed-Proof White into the stem color if needed. A thin line of white will help the bird's beak or tail stand out against a darker background.

Geraniums
Watercolor on 300-lb. (640gsm) cold-pressed paper
13" × 10" (33cm × 25cm)
Private collection

Teacups

If these cups could talk, what stories they could tell! They've been used for happy times, celebrating marriages and births, and for sad occasions. They were packed and moved from one country to another and have been handed down from one generation to the next. Perhaps this is why these cups are so special to me. What better way to preserve them than to paint them?

This demonstration uses a vignette style of painting to show off the subject matter. The beauty and delicacy of the teacups show more dramatically against a white background.

Materials List

Surface
300-lb. (640gsm) cold-pressed paper

Paint
Alizarin Crimson ❖ Aureolin
Cobalt Blue ❖ French Ultramarine Blue
New Gamboge ❖ Permanent Rose
Raw Sienna ❖ Winsor Green

Brushes
no. 8, no. 4 rounds

Other
2H pencil ❖ Kneaded eraser

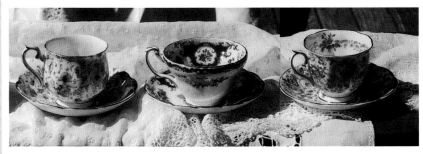

Pay Attention to the Direction of Light
It's easier to photograph all the teacups together so that the light source is the same. Take a close-up photo of each teacup and then take another that shows all the teacups in one shot. Tape the closeups together for a clear reference photo.

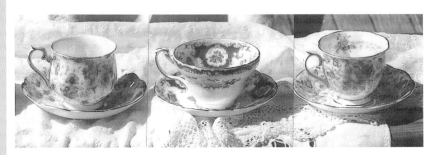

Value Reference
A halftone copy of your reference will help you understand the values on the teacups. You can do this on a photocopier.

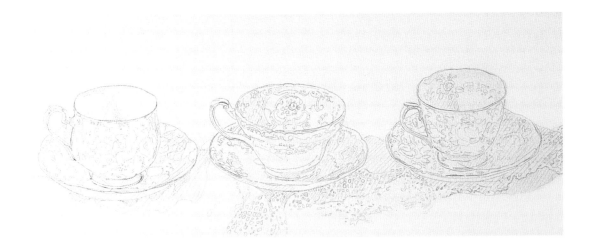

1 Complete the Drawing

The complicated patterns on teacups can make them difficult to draw. Don't let the drawing process stop you from painting. The more you paint, the more your drawing skills will develop. If drawing is a problem, trace the reference photo. Or do your initial drawing on tracing paper, working out problems and erasing on the tracing paper rather than on your watercolor paper. Use a 2H pencil and a kneaded eraser.

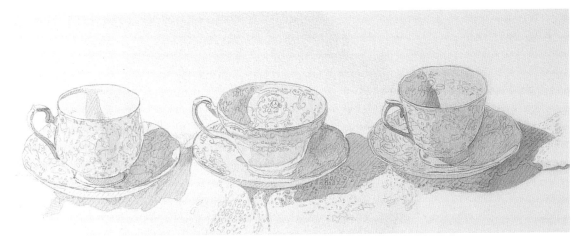

2 Establish the Underlying Colors

Decide which areas are going to remain the white of the paper and keep these areas unpainted, as the lightest value. Use your no. 8 brush to paint the lightest shadows on the teacups. Paint the cup on the left with a lighter medium value of Cobalt Blue in some places, Aureolin in others. For the center cup, use a Cobalt Blue and Permanent Rose mixture, varying the ratio of blue to rose. For the cup on the right, use a Permanent Rose and Raw Sienna mixture. Don't forget to paint the cup handles.

Paint the shadows on the lace the same way as the teacups, using Cobalt Blue and a Cobalt Blue-Permanent Rose mixture. The cups on the left and right create a little Raw Sienna shadow on the lace.

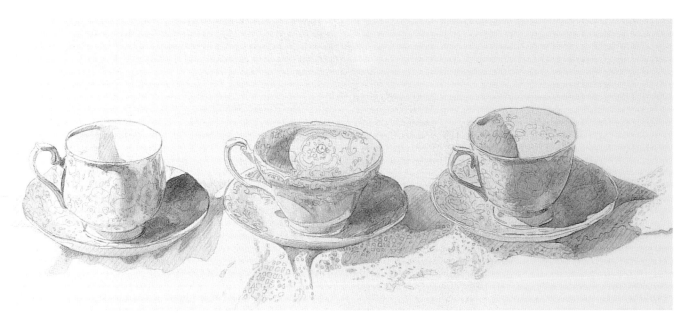

3 Deepen the Color

With your no. 8 brush, paint the medium-dark shadows on the cups. On the left cup, use a medium value of Cobalt Blue, adding darks on the center and the right side. Use a mixture of Cobalt Blue and Permanent Rose for the middle cup, using more blue for the right side of the saucer and more pink for the cup. Strengthen the shadow values on the right teacup using Permanent Rose and Raw Sienna. As you paint these cups, remember that you don't want to cover up all of the previous lighter value. This is how you build values from light to dark.

Paint the medium values on the lace with Cobalt Blue and Raw Sienna.

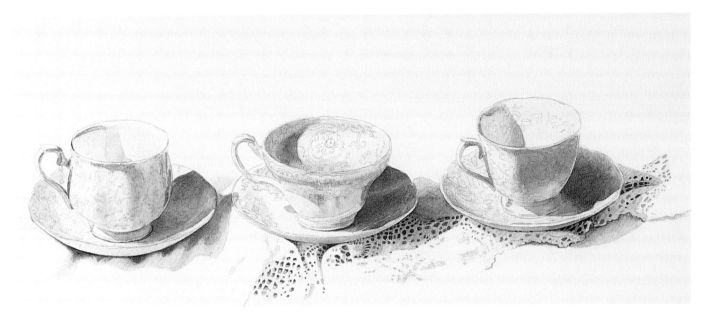

4 Get Darker

Use the darkest value of the same colors that you used on the lace and teacups in the previous step, and finish the darkest detail in the shadows using your no. 8 brush. Switch to your no. 4 brush and use a mixture of Permanent Rose and Cobalt Blue to paint the lace holes. Just suggest the lace; don't get too picky!

Are the values on your teacups dark enough? It's important that you have strong values to make these cups look round.

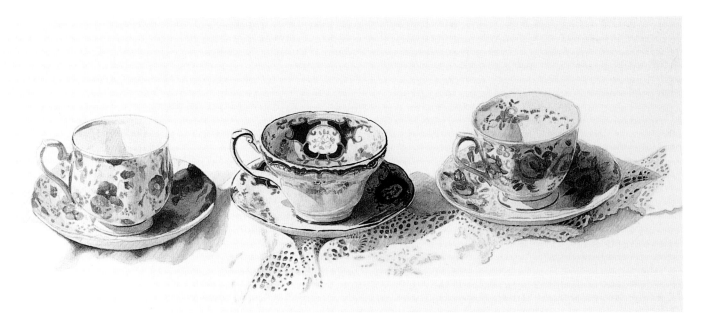

5 Paint the Teacup Patterns

Starting with the teacup on the right, use your no. 4 brush and a light value of Permanent Rose to paint the pink roses on the cup and saucer. When this is dry, use a darker-value mixture of Permanent Rose and Cobalt Blue to paint the medium values on the roses.

Mix a medium value of Alizarin Crimson and Cobalt Blue for the burgundy pattern on the center cup. You can paint the dark pattern on the right side of the saucer, but you might have to redraw the teacup pattern if it doesn't show through the shadow. Use a mixture of Alizarin Crimson, French Ultramarine Blue and a little Winsor Green for this.

Use a light value of Cobalt Blue to paint the pansies on the left teacup. When it dries, paint the medium values on the pansies using a medium value of Cobalt Blue.

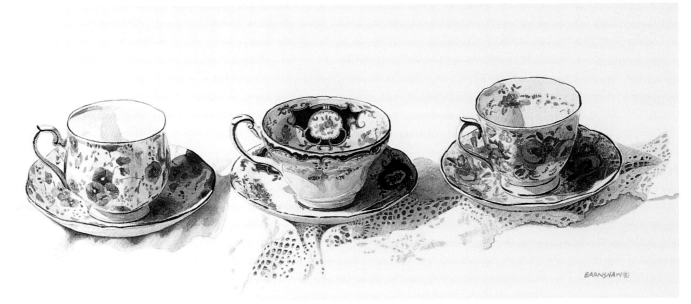

EARNSHAW ©

6 Complete the Darks and Details

Use your no. 4 brush to paint the gold trim on all three cups using New Gamboge. When this is dry, paint the dark detail over the yellow with a dark mixture of Alizarin Crimson, French Ultramarine Blue and Winsor Green.

Use Alizarin Crimson to paint the centers of the blue pansies on the left teacup.

Paint the final detail on the center teacup. The trim around the burgundy panels is Raw Sienna.

Now detail the rose teacup on the right.

I hope this step-by-step demonstration has made it clear to you why glazing or working in layers makes it easier to paint complicated subject matter.

Legacy
Watercolor on 300-lb. (640gsm) cold-pressed paper
8" × 20" (20cm × 51cm)
Private collection

conclusion

I hope I have convinced you that your attitude is more important than your talent. Painting is rewarding and can be life-changing. If you get discouraged, you must believe me when I say that you are capable of painting well. Like anything else in this life, the more you do it, the better you get. If you truly want to become a successful artist, you must make the commitment.

In your personal journey to become an artist, make a real effort to find your own way of painting. Take what I teach and give it your individual stamp. Your ideas may be better than mine. You may have a better way of painting than I do. But you won't find out unless you give it a shot. No guts, no glory!

When my son was small, I tucked him into bed one night and went into my studio to paint. After a few minutes, I heard a small voice call, "Mom, what are you doing?"

"Painting," I said.

His sleepy voice replied, "Good."

High Hopes
Watercolor on 300-lb. (640gsm) cold-pressed paper
30" × 8" (76cm × 20cm)
Private collection

The Roost
Watercolor on 300-lb.
(640gsm) cold-pressed
paper
34" × 43" (86cm × 109cm)
Permanent collection of the
Leigh Yawkey Woodson
Art Museum

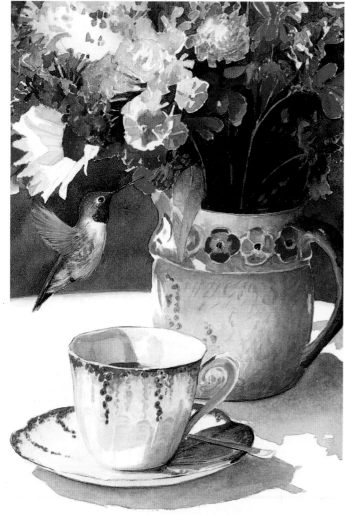

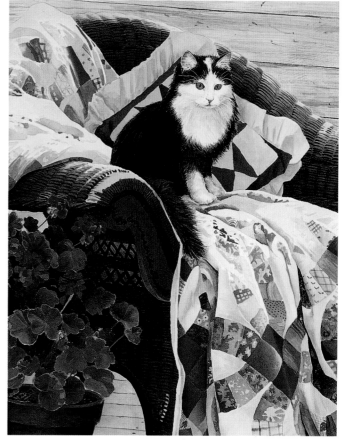

May Dance
Watercolor on 300-lb. (640gsm)
cold-pressed paper
12" × 8" (30cm × 20cm)
Private collection

Whiskers and Wedding Rings
Watercolor on 300-lb. (640gsm) cold-pressed paper
18" × 14" (46cm × 36cm)
Private collection

Index

Paint more of the things you love with North Light Books!

PAINTING
FLOWERS
IN WATERCOLOR

WITH charles REID.

Charles Reid is one of watercolor's best-loved teachers, a master painter whose signature style gorgeously captures bright floral still-lifes. In this book, Reid provides the instruction and advice you need to paint fruits, vegetables and flowers that glow. Special "assignments" and step-by-step exercises help you master techniques for wild daffodils, roses, mums, sunflowers, lilacs, tomatoes, avocados, oranges, strawberries and more!
ISBN 1-58180-027-4, hardcover, 144 pages, #31671-K

Beautifully illustrated and superbly written, this wonderful guide is perfect for watercolorists of all skill levels! Gordon MacKenzie distills over thirty years of teaching experience into dozens of painting tricks and techniques that cover everything from key concepts, such as composition, color and value, to fine details, including washes, masking and more.
ISBN 0-89134-946-4, hardcover, 144 pages, #31443-K

The
Watercolorist's
Essential
Notebook

A treasury of watercolor tricks and techniques discovered through years of painting and experimentation

Gordon MacKenzie

watercolor
pour it on!
Let your creativity flow using
dramatic color glazing techniques

jan fabian wallake

Take advantage of the transparent, fluid qualities of watercolor to create startling works of art that glow with color and light! Jan Fabian Wallake shows you how to master special pouring techniques that allow pigments to run free across the paper. There's no need to worry about losing control or making mistakes. Wallake empowers you to trust your instincts and create glazes rich in depth and luminosity.
ISBN 1-58180-161-0, hardcover, 128 pages, #31910-K

plein air PAINTING
IN WATERCOLOR & OIL

PAINT FROM LIFE
SUCCESSFULLY

FRANK LaLUMIA

Frank LaLumia shows you how to capture nature's three-dimensional glory in watercolor and oil at any time and place. You'll learn the basics of rendering natural light and color, how different paints can affect your plans for working in the field, and how fluency in the language of painting allows you to capture those extraordinary, magical happenings in the world beyond your window.
ISBN 0-89134-974-X, hardcover, 128 pages, #31666-K

These books and other fine North Light titles are available from your local art & craft retailer, bookstore, online supplier or by calling 1-800-289-0963.